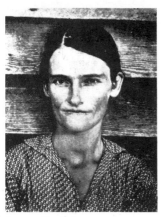

Leonora Carrington

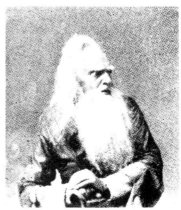

Max Ernst

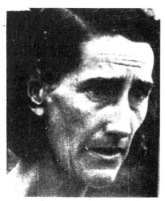

Marcel Duchamp

André Masson

COMPENSATION PORTRAITS

René Magritte

Pablo Picasso

André Breton

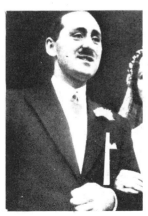

Benjamin Péret

TRANSLATIONS:
ALEXIS LYKIARD,
JENNIFER BATCHELOR

DESIGN:
JULIAN ROTHENSTEIN

SPECIAL THANKS TO:
JEAN-LOUIS BÉDOUIN, VINCENT BOUNOURE, ELISA BRETON,
ROGER CARDINAL, AURÉLIEN DAUGUET, RIKKI AND GUY
DUCORNET, AUBE ELLÉOUËT, DAVID GASCOYNE,
JEAN-MICHEL GOUTIER, PAUL HAMMOND, EDOUARD
JAGUER, ALEXIS LYKIARD, JOHN LYLE, MARCEL MARIËN,
ANTONY MELVILLE, RENÉ PASSERON, MICHAEL
RICHARDSON, ANTONY ROE, JEAN SCHUSTER, ARTURO
SCHWARZ, JEAN-CLAUDE SILBERMANN, RACHEL STELLA,
MICHEL ZIMBACCA, STEVEN ZIVADIN (VANE BOR).

TRAVAIL · INSTRUCTION · PROGRÈS

A BOOK OF

SURREALIST SURREALIST
GAMES

INCLUDING THE LITTLE SURREALIST DICTIONARY
COMPILED AND EDITED BY ALASTAIR BROTCHIE
EDITED BY MEL GOODING

SHAMBHALA REDSTONE EDITIONS
BOSTON & LONDON 1995

SHAMBHALA PUBLICATIONS, INC.
HORTICULTURAL HALL
300 MASSACHUSETTS AVENUE
BOSTON, MASSACHUSETTS 02115

THE PUBLISHER IS GRATEFUL TO THE FOLLOWING
COPYRIGHT HOLDERS FOR PERMISSION TO REPRODUCE
MATERIAL: ATLAS PRESS, AMIS DE BENJAMIN PERET,
LIBRAIRIE JOSE CORTI, EDITIONS DU SEUIL, MRS. D. BURGI,
DACS; TO EDITIONS GALLIMARD FOR *L'UN DANS L'AUTRE* FROM
PERSPECTIVE CAVALIERE. ANDRÉ BRETON, 1970; *TOUJOURS LES
MÊMES* FROM *OUVRES COMPLETES*, ANDRÉ BRETON, 1988;
RECHERCHES SUR LA SEXUALITÉ FROM *ARCHIVES DU
SURREALISME*. ANDRÉ BRETON, 1988; AND *MOTS SANS MEMOIRE*.
MICHEL LEIRIS, 1969; AND TO SPADEM/ADAGP, PARIS,
AND DACS, LONDON, FOR WORKS BY MAX ERNST
AND RENÉ MAGRITTE

9 8 7 6 5 4 3 2 1

PRINTED IN THE UNITED STATES OF AMERICA
ON ACID-FREE PAPER
DISTRIBUTED IN THE UNITED STATES BY
RANDOM HOUSE, INC., AND IN CANADA BY
RANDOM HOUSE OF CANADA LTD

SEE PAGE 175 FOR LIBRARY OF CONGRESS
CATALOGING-IN-PUBLICATION DATA

A BOOK OF SURREALIST GAMES

CONTENTS

SURREALIST GAMES

Poetry should be made by all (Lautréamont)

The Surrealists initiated the most radically liberating critique of reason of the century. Their brilliant investigations were conducted through art and polemic, manifesto and demonstration, love and politics. But most specially and remarkably, it was through games, play, techniques of surprise and methodologies of the fantastic that they subverted academic modes of enquiry, and undermined the complacent certainties of the reasonable and respectable. Playful procedures and systematic stratagems provided keys to unlock the door to the unconscious and to release the visual and verbal poetry of collective creativity.

These methods and experiments were at the centre of the Surrealist provocation of bourgeois normalities. They borrowed children's games, invented techniques to exploit the unpredictable outcomes of chance and accident, and discovered new and creative uses for automatism. To facilitate their own researches into the secrets of the human heart and mind they appropriated, with magisterial *insouciance,* procedures of enquiry from the academic disciplines of psychology, sociology, anthropology and philosophy. They arbitrarily tranformed innocent objects into magical images, and reinstated the fetish in the ceremonies of art.

Surrealist games and procedures are intended to free words and images from the constraints of rational and discursive order, substituting chance and indeterminacy for premeditation and deliberation. Surrealism takes the logic and continuity of the dream to have a truly *given* significance, equalled only by the revelatory power of the unexpected analogy, the marvellous conjunction: . . . *I madly love everything that adventurously breaks the thread of discursive thought and suddenly ignites a flare illuminating a life of relations fecund in another way* wrote Breton. Such 'chance encounters' transgress

deductive laws and transcend the logical systems of classical rationalism.

Such relations — the *spontaneous, extra-lucid, insolent rapport ... between one thing and another ... which common sense hesitates to confront* — may be discovered in dreams, in the mental play of poetic reverie, in the induced trance and the *systematic disordering of the senses* famously prescribed by Rimbaud, and in the practice of automatic techniques. To these solitary exercises of the imagination, significantly freed in each case from the composing rules of logical discourse, the Surrealists added the absorbing and ordered procedures of creative collaboration and the game. These activities they valued especially for their emphatic repudiation of individualistic artistic value, and their potential for collectively achieved revelation.

They have those characteristics of games defined by Roger Caillois, the French critic associated for a time with the Surrealists: they are freely entered into; separated from the run of ordinary 'serious' life, they are circumscribed by their own time and space; they are uncertain, their outcomes not predetermined; they are economically unproductive and not concerned with material interests; they are governed by rules; they are associated with imaginative projection and make-believe. In elaborating the famous definition provided by Huizinga in HOMO LUDENS thus far, Caillois might have added that they are entered into for pleasure, and may bring unpremeditated insights. In many of these aspects they have much in common with art.

In one particular and important respect Surrealist play is more like a kind of provocative magic. This is in its irrepressible propensity to the *transformation* of objects, behaviour and ideas. In this aspect of its proceedings Surrealism makes manifest its underlying political programme, its revolutionary intent. The First Manifesto ends: *It [Surrealism] leads to the permanent destruction of all other psychic mechanisms and to its substitution for them in the solution of the*

principal problems of life. Sweeping and vague as it is, it cannot be doubted that this grand ambition was serious. Subsequent publications and manifestos developed and elaborated a complex of insights relating the life of the individual psyche to the dynamics of society and history, some powerfully original, some simplistic, some absurdly extreme or utopian. This is not the occasion for a history of Surrealist political interventions and provocations, nor for the re-telling of the complex story of its own political travails, the bitter arguments, confrontations, expulsions and reconciliations. But there is no other movement in the history of this troubled century, surely, which has linked ideas of revolutionary political change so closely to the operations of magical transformation in art and poetry, and sought to subvert familiar social relations and received ideas in every sphere by subjecting them to rigorously witty and fantastic interrogations.

Here collected for the first time is a compendium of Surrealist games, strategies and procedures. It is for those who wish to employ for themselves the techniques of Surrealist enquiry and discovery; it sets out the rules and directions for playing the games. There has been nothing like it: much of the material gathered here has been previously documented only in obscure journals, or in magazines long since defunct and difficult to come by. It is presented in the spirit of its subject, to offer the means to fulfil those aims (among others) of Surrealism described by its early historian, Julien Levy:

To exploit the mechanisms of inspiration.

To intensify experience.

We have lived for too long in the dreary region of *homo economicus,* our lives shadowed by principles of self-interest, utilitarian 'necessities', instrumental moralities. But we are permitted to hope; to revive those great and optimistic words of Breton: *Perhaps the imagination is on the verge of recovering its rights.* We must welcome, as did the Surrealists, the re-entry into modern life of *homo ludens,* the imaginative man at play, the intuitive visionary.

MEL GOODING, 1991

LANGUAGE GAMES

AUTOMATISM

THE PRIMARY METHOD OF SURREALISM. AS A
PROCEDURE IT FORMS PART OF MANY OF THE GAMES AND
ACTIVITIES DESCRIBED IN THIS BOOK.
SOLITARY AND COLLECTIVE AUTOMATIC TECHNIQUES, AND THE
EXPLOITATION OF *CHANCE* ARE CENTRAL TO MANY SURREALIST
GAMES. THE ORIGINAL SURREALISTS SOON CAME TO REALIZE THE
LIMITATIONS OF 'PURE AUTOMATISM'. AUTOMATIC TECHNIQUES
MAY BE USED AS A **BEGINNING** OF CREATIVE ACTIVITY, TO
STIMULATE AND ENCOURAGE SPONTANEITY OF UTTERANCE OR
IMAGE-MAKING.

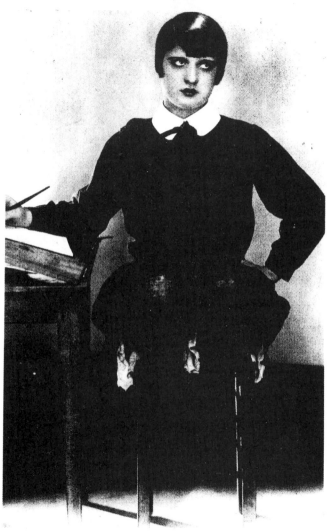

The Muse of Automatic Writing

A U T O M A T I C W R I T I N G

Automatic writing is the most direct of Surrealist techniques.

Sit at a table with pen and paper, put yourself in a 'receptive' frame of mind, and start writing. Continue writing without thinking about what is appearing beneath your pen. Write as fast as you can. If, for some reason, the flow stops, leave a space and immediately begin again by writing down the first letter of the next sentence. Choose this letter at random before you begin, for instance a 't', and always begin this new sentence with a 't'.

Although in the purest version of automatism nothing is 'corrected' or re-written, the unexpected material produced by this method can be used as the basis for further composition. What is crucial is the unpremeditated free-association that creates the basic text. Apart from the passage by Breton and Soupault, the examples here have been re-worked to a greater or lesser extent. They have been chosen to demonstrate a range of automatic writing, from the humour of Péret to the magical stories of Desnos to the more aggressive stance of the black poet Aimé Cesaire. The first example is from THE MAGNETIC FIELDS, *the first Surrealist book of purely automatic texts.*

HONEYMOON

To what are mutual attractions due? There are some jealousies more touching than others. I willingly wander in such baffling darkness as that of the rivalry between a woman and a book. The finger on the side of the forehead is not the barrel of a revolver. I believe that although we paid heed to each other's thinking, the automatic 'Of nothing' that is our proudest denial did not once need to be uttered during the whole wedding-spree. Lower than the stars there is nothing to stare at. No matter what train you may be travelling in, it is dangerous to lean out of the carriage-door window. The stations were plainly distributed about a bay. The sea that to the human eye is never so beautiful as the sky did not leave us. In the depths of our eyes disappeared neat reckonings bearing on the future like those of prison walls.

ANDRÉ BRETON AND PHILIPPE SOUPAULT

FROM THE HONOURABLE MINISTER OF DELICATE INSTRUMENTS

TO MISS LANTERN

My dear friend,

Believe me that I was sincerely afflicted when I learned of the loss you have suffered: a steam-powered urinal is not easily replaced. Yours, which had among other precious peculiarities, the ability to sing the *Marseillaise* when in use, was certainly worthy of the esteem you bestowed upon it. So, it is easy for me to understand the despair that your sister felt when it became evident that the urinal was definitively lost. Nevertheless, from that to suicide is quite a step! And, although I know that many fond memories were associated with its possession, I cannot but condemn such a fatal resolve. But this censure does not prevent me from profoundly deploring her sad end. A suicide is always, for those close to the deceased, a tragic and agonising event; but when it is accomplished by means of jam, one cannot be less than terrified. Never would I have believed that your sister could resolve to die embedded in a vat of jam! And yet, all those unlucky enough to befriend her knew of her almost morbid attraction to jam, even in jars. Do you remember how she could not contain herself when she saw it with desserts, how she had to caress it even before serving herself? Numerous incidents of this nature should have aroused our suspicion; but, blind that we were, we never understood their profound significance. Her love of jam was in the end but the love of death by jam; and it took the completion of her fatal gesture for us to understand it all. Nonetheless, I shiver at the thought of how her last moments must have been.

Please believe that I share your pain, and approve of your decision to banish jam from your life. This is a healthy reaction and I can only commend it from the bottom of my heart. It demonstrates both your determination, and your courage in overcoming pain, as well as your instinct for self-preservation. I am truly glad that without jam, you do not, indeed, risk letting yourself be compelled to follow the example of your sister.

BENJAMIN PÉRET

In a Northern town there was an amazing barometer to which storms and rain, sun and snow would come for their instructions. One day the most distant ocean waves, those that bathe desert islands and the ones in which washerwomen do their laundry, wanted to see the mysterious tyrant who ruled over equinoxes and shipwrecks. They came hurtling up to attack the town. For seven days and seven nights the inhabitants defended themselves with rifle and cannon against what they called the liquid barbarism. They were overcome and the eighth day's obedient sun illumined their corpses, presided over their decomposition and saw the majestically pacific waves throng to bring their tribute of spume to the tyrant barometer which, unconcerned by such homage, pondered how, far away—and saved by the foam's sacrifice—a blonde virgin and a pirate clad in a pale blue dolman, were embracing upon weed laid across the sea-bed which had been deserted by its water at the very moment that the S. S. MARVEL, on which they were travelling, went down.

ROBERT DESNOS

NOON KNIVES

When Niggers make the Revolution they start by uprooting gigantic trees from the Champ de Mars they hurl them at the sky's face like howlings in the warmest air they take aim at pure streams of cool birds and fire blanks at them. They fire blanks? Yes indeed because this whiteness* is exactly the controversial colour of the blackness they carry in their hearts and which never ceases to conspire in the tiny too-perfect hexagons of their pores. The white gun-shots then plant in the sky beautiful whores who are not unrelated to the coifs which the Sisters of Saint Joseph de Cluny scrub beneath the wine and hosts of noon amid the solar jubilation of tropical soap.

Noon? Yes Noon that disperses in the sky the subservient cotton wool that muffles my words and traps my screams. Noon? Yes Noon almond of night and tongue between my pepper fangs. Noon? Yes Noon which carries across its shoulders of an outcast and a glazier all the sensitivity for hatred and ruins that matters. Noon? Of course Noon which confesses with my lips the moment of blasphemy and at the cathedral limits of laziness puts down on every line of every hand the trains that repentence held in reserve in the strongboxes of rigid time. Noon? Yes sumptuous Noon that absents me from this world.

Sweet Lord!

pitilessly I spit. Into the face of the starvers, into the face of revilers, into

*In French 'blanc' means both 'blank' and 'white'

the face of the embalmers and the eviscerators.
Pitiless Lord! sweetly I whistle; I whistle sweetly
sweetly like the glass of catastrophe
sweetly like the greatcoat of bird feathers that vengeance wears after
crime
sweetly like the greeting of tiny waves surprised in their petticoats in
the chambers of the manchineel
sweetly like a river of mandibles and the parrot's eyelid
sweetly like a rain of ash empearled with tiny fires
Oh! I keep my pact
upright in my wounds where my blood beats against the shafts of ship-
wreck the cadavers of croaked dogs from which hummingbirds fly out,
this is the day,
a day for our fraternal feet
a day for our hands without rancour
a day for our breathing without mistrust
a day for our faces to be shameless
and the Niggers go searching in the dust—with jewels in their ears sing-
ing loud as they can—for the shards which mica is made from which
moons are made from and the lamellated slate from which sorcerers
construct the intimate ferocity of the stars.

AIMÉ CESAIRE

SIMULATION

A modification of automatic writing is the technique of simulation.

*Instead of assuming a passive or 'receptive' frame of mind, one can with practice assume an active mental state not one's own. Given this mental set—for instance, that of a delirious mental 'illness'—one attempts to write **from within it.***

The outcomes of simulation are not always solemn.

ATTEMPTED SIMULATION OF MENTAL DEBILITY

Among all men, at the age of twenty four, I realised that to rise to the position of a respected man one need have no more consciousness of one's own value than I had. I maintained a long time ago that virtue is not appreciated, but that my father was right when he wanted me to raise myself high above his contemporaries. I utterly fail to see why they should give the Legion of Honour to foreign personalities passing through France. I feel that this decoration should be reserved for officers who have done deeds of valour and mining engineers who graduate from the Polytechnique. In fact the grand master of the Order of Chivalry must be short of common sense if he recognises merit where there is none. Of all distinctions, that of officer is the most flattering. But one cannot do without a diploma. My father gave his five children, boys and girls, the best education and a good upbringing. And not so that they would accept a barely-remunerated job in an administration which does not pay. And the proof is that when someone is capable, like

my elder brother, who has appeared on several occasions in the papers, of scoring a bullseye against bachelors of arts and bachelors of science, you can say you have someone to take after. But sufficient unto the day, as the proverb goes.

In the inside pocket of my summer jacket I have the plans of a submarine that I wish to offer to the Ministry of Defence. The captain's cabin is drawn in red ink and the torpedo cannons are the latest hydraulic model, with artesian control. Cycling champs do not show greater energy than me. I make no bones about my firm conviction that this invention must be a success. Everyone is a supporter of Liberty, Equality and Fraternity, and, may I add, mutual Solidarity. But that is no reason not to defend ourselves against attack from the sea. I have written a *secret* letter on vellum paper to the President of the Republic, requesting to see him. The Mediterranean Squadron is right now cruising off Constantina, but the admiral is giving too much leave. However humbly a soldier kneels before his C.O., orders are orders. Discipline is best when the leader is just, but firm. Stripes are not awarded at random and Maréchal Foch thoroughly deserved to be Maréchal Foch. Free thinking made the mistake of not devoting itself to the service of France.

I also feel strongly that another name should be found for the Marine Infantry. I have also approached the League for the Rights of Man in this regard. The name is unworthy of their sailor's collars. Besides, it is up to them to make themselves respected. The Greece of Lacedaimon was made of sterner stuff. Still, man believes in God and the toughest nuts have been known to ask for extreme unction, which is a step in the right direction.

ANDRÉ BRETON AND PAUL ELUARD

CHAIN GAMES

THESE ARE GAMES TO BE PLAYED COLLECTIVELY, AND CAN BE PLAYED
BY ANYONE. THE STRANGE CONJUNCTIONS, HUMOROUS OR POETIC,
THAT THEY GENERATE GIVE THEM THEIR POINT. NO ONE IS
EXCLUDED FROM THE QUEST FOR REVELATION.
THE FIRST FIVE GAMES USE THE TECHNIQUE OF PAPER-FOLDING TO
HIDE PREVIOUS PLAYERS' CONTRIBUTIONS, AND ALL HAVE
AUTOMATIC ASPECTS.

THE EXQUISITE CORPSE

For a minimum of three players.

The players sit around a table and each writes on a sheet of paper a definite or indefinite article and an adjective, making sure their neighbours cannot see them. The sheets are folded so as to conceal the words, and passed round to the next player. Each player then writes a noun, conceals it, and the process is repeated with a verb, another definite or indefinite article and adjective, and finally another noun. The paper is unfolded and the sentences read out. Players may agree small changes to ensure grammatical consistency.

This is the simplest version of the game, more complicated sentence structures can be agreed beforehand.

The game acquired its name from the first sentence obtained in this way:

The exquisite corpse shall drink the new wine.

Further examples:

The wounded women disturb the guillotine with blond hair.

Caraco is a lovely bitch: lazy as a dormouse and gloved in glass so as not to have to do a thing, she strings pearls to pay the piper.

The avenged topaz shall devour with kisses the paralytic of Rome.

The flame-coloured breast surpasses by one step, one finger, one mouthful, the melodious breasts.

The endless sex sleeps with the orthodox tongue.

DEFINITIONS
OR QUESTION AND ANSWER

For two or more players.

The procedure is similar to that of the previous game. A question is written down, the paper folded to conceal it from the next player, who writes an answer.

The paper is unfolded to reveal the result. Remarkable facts emerge.

What is equality?
It is a hierarchy like any other.

What is reason?
A cloud eaten by the moon.

What is suicide?
Several deafening chimes.

What is physical love?
Half of pleasure.

Why go on living?
Because at prison gates only the keys sing.

What is absence?
Calm, limpid water, a moving mirror.

What is military service?
The noise of a pair of boots tumbling down a staircase.

What is day?
A woman bathing nude at nightfall.

What is a torrent of blood?
Shut up! Delete that abominable question.

CONDITIONALS

For two or more players.

The same procedure as before, but in this case the first player must write a hypothetical sentence beginning with 'If' or 'When', then conceal it. The second player writes a sentence in the conditional or future tense.

If there were no guillotine

Wasps would take off their corsets.

When children strike their fathers

All young people will have white hair.

If octopi wore bracelets

Ships would be towed by flies.

If your shadow's shadow visited a hall of mirrors

The sequel would be postponed indefinitely until the next issue.

If mercury ran till it was out of breath

Believe me, there'd be trouble.

SYLLOGISMS

For three players.

 Using the same procedure as the preceding games, the three players construct a syllogism. The first player writes down the first premise, a proposition beginning with 'All', then conceals it by folding the paper. The second player writes down the second premise and conceals it. The third player writes the conclusion, beginning with 'Therefore'. The syllogism is then read out.

 All aristocrats look with terror at the scaffold.
 There's nothing at all on the desert's arid palm.
 Therefore the falling salt is a handkerchief.

OPPOSITES

For a minimum number of three players.

 The first player writes a sentence, a question or a statement, at the head of a sheet of paper, and passes it to the next player. This player writes the absolute opposite of this sentence, phrase by phrase, according to any idea of 'opposite'. He then folds the sheet to cover only the first sentence. This has the effect of transforming the negation into an affirmation, which the third player must, in turn, negate. Before passing on the sheet, this player also folds it, but only so as to cover the previous sentence. This process may continue as long as the players desire, or the paper allows.

 When my mother swigs champagne.
 My father's corpse gets drunk on chianti.
 Our mothers' infants dry up tearlessly.
 The moribund waters my fatherland.
 An infant dessicates our universe.
 An old corpse waters their afterlife.
 Two infants absorb what precedes death.

<div align="right">M SANDOZ, F R SIMON, M ZIMBACCA</div>

ECHO POEMS

For one, two, or more players.

 The aim is to write a poem whose two halves, laid out in two columns, echo one another. The 'echo' may be achieved in various ways: by the phonetic correspondences of rhyme or half rhyme, by puns, by rearranging syllables; or by methods which do not depend in any way upon the phonetic properties of the words. One might use, for example, the literal or free-associating 'opposites' of the previous game, as in the poem below.

 Write the first sentence in the left-hand column. The last part of this sentence is then transformed into the first part of the sentence in the right-hand column (in the example, 'the migrant triangles' become 'the circular suggestion'). The second sentence is then completed however one chooses, and this part generates the first half of the second sentence in the left-hand column ('fickle fleeces' become 'faithful plumage' etc.), and so on.

 The poem's title is the 'echo' of the final phrase.

WHEN THE FLEETING SUMMER LETS OUT PUBLIC SCREAMS

One isolates this pure theft
this breath imposed upon the
migrant triangles.

As for the faithful plumage,
it's iced up by the take-off
of swings caught up in plaits
of black wheat.

The calm sea-urchins' pardon
is obtained through the
dismemberment of the living.

The circular suggestion hibernates within
the fickle fleeces that quiver
expectantly.

And the court's dock, freed from
the tonsure of granite, asks a favour of the
questing trapdoor spiders.

Lifted from solid corpses, it is the
tenacious winter which preserves its
sway over secret glances.

AURÉLIEN DAUGUET

ONE INTO ANOTHER

For a minimum of three players, although a larger number is preferable.

One player withdraws from the room, and chooses for himself an object (or a person, an idea, etc.). While he is absent the rest of the players also choose an object. When the first player returns he is told what object they have chosen. He must now describe his own object in terms of the properties of the object chosen by the others, making the comparison more and more obvious as he proceeds, until they are able to guess its identity.

The first player should begin with a sentence such as 'I am an (object) . . .'

I am a very beautiful female BREAST, particularly long and serpentine. The woman bearing it agrees to display it only on certain nights. From its innumerable nipples spurts a luminous milk. Few people, poets excepted, are able to appreciate its curve.

MILKY WAY BENJAMIN PÉRET

I am a CHRISTMAS TREE seen several days after the festivities. My top is triangular like all christmas trees. Like them I hold some surprises in store for children, but also continue to affect a certain category of adults in that I participate simultaneously in times past and present.

ATTIC ELISA BRETON

I am a hardened SUNBEAM that revolves around the sun so as to release a dark and fragrant rainfall each morning, a little after midday and even once night has fallen.

COFFEE-MILL JEAN SCHUSTER

I am a gleaming NECKTIE knotted around the hand so as to run across those throats at which I'm placed.

SWORD TOYEN

31

THE GAME OF VARIANTS

For any number of players.

This is simply the parlour-game 'Chinese Whispers'. The company sits in a circle. The first player whispers a sentence to his neighbour, who whispers the same sentence to the next player, and so on. The first and last sentences are then compared.

Is it love? Is it life? Is it love of life or lees of love?
Is it love? Is it life? Is it life-line? Or demise?

You must dye blue the pink bags fathomed by orange parapets.
At all costs forget the fifth paragraph of 'Paradise Lost'.

TRANSLATION POEMS

For any number of players. (This game can also be played by post.) This is really an advanced form of the Game of Variants.

A poem is sent by the first player to the next, who translates it into another language, sending this version on to the next player, and so on. At the conclusion, each poem is regarded as an original work in its own right, created collectively by the processes of inadvertent transformation. (The extraordinary effects of these processes can be best seen if the final version in the sequence is in the same language as the first.)

In a variant of this game the transformations can be exaggerated by the introduction of arbitrary procedures, like those used in other games, such as phonetic echoes; 'opposites'; etc.

THE GAME OF ILLÔT-MOLLO

For two, or preferably three or four, players.

A method for writing prose texts. The players begin writing, and as they do so, each in turn, in strict rotation, speaks aloud a word from the phrase he is writing at that moment. The other players must incorporate this 'marker-word' into their text, immediately coupling it with another word, which remains secret. Proceeding thus (marker-word + secret word), each player writes a text which parallels that of the other players. The marker-words and the secret words may be joined in whatever way the players choose.

In the examples below, marker-words are italicised.

Player A

Your *hair* of *rare* feather swims in the vulnerable *night* that *spreads* upon folds of inaccessible *fog.* This *evening* I'm bogged down and your damp *shoulders end* up burying me under the *gaze* of the *veiled* bird of smiles and mad *laughter.* Come at *daybreak*,* under the murderous *flames, drowsy* from homecoming. *Boredom* leaks from the *wells* around your *devil's* eyes, in which the *glow-worm* is born. Here I *designate* under the strength of unknown *territories,* the little-*known* discord of hands *painted* on an *eye,* the limpid *open* eye of the night.

Player B

The *hair* of Death is *rare* in the *night,* the night, night wherein it *spreads* no *fog.*

The fog is dismal, the *evening* too, and *shoulders* sob, an *end* to childhood.

A *gaze* reached us through the *veil* and I *laughed* suddenly. *Full-stop** perhaps. *Flame* and love. To *drowse* tomorrow from *boredom* retrieved from its *well* of ferns where *devils* danced.

The *glow-worm* of the seas *designates* its victims and the *territories* of foot-prints are *known* in the town, where our wakings are *painted.* An *eye* wends its way there and *opens,* opens.

*In French 'point du jour' = day-break, 'point' = full-stop.

PARALLEL STORIES

For two, preferably three or four, players.

Similar to the previous game, but simpler. Once again the players each write a text and must integrate into it 'marker-words' which are announced in turn by the players. In this case there is no rule concerning hidden words and the frequency of the 'marker-words' is not necessarily specified.

Alternatively the 'marker-words' may be announced by someone outside of the game, or may be recorded on a tape-recorder beforehand.

In this example, 'marker-words' are italicized in the text of the player who introduced them into the game.

THE PEANUT

. . . Greek fire in the *drawers* of thought, what then does the otter think? This star which dies in the shoe-tree that an estuary of furs opens with stampeding cries uttered upon the *canoe* pavements of thought. They're everywhere, the black insects spring devours — substitute, space is a liqueur — . I drink at the stroke of fate. The castle overflows with *sharks* which the dogs' presence excites, among the artichokes of madness. Whereas the fencer flashes with ague that a *haywain* communicates to the compass card. It's here says the gravedigger guiding

his shears into the skulls piled up on the wireless set. I'm not a *baker* says one of them without conviction since the scarf around his neck is choking him while a hammer wakes him up.

<div align="right">MICHELINE BOUNOURE</div>

. . . no, not at all it was a drawer full of *shoetrees* which resembled the Somme Estuary at low tide when the vases uncovered the dead plumbers in the green canoes like *substitutes* for mint spirits in a glass. And space grew greater further out in the shark's direction as he circulated, alert as an *artichoke* flowering in the wind of June peopled with fencers in the guise of birds and haywains that waddled along playing at *shears* on the crania of the children of the baker who rightly dashed upon his *hammer.*

<div align="right">VINCENT BOUNOURE</div>

. . . old ladies' drawers serve as shoetrees in the *estuary* of the canal so as to block the substitute canoes of the sailing billiards. The free *space* lets pass the sharks laden with baskets of artichokes destined for the *fencers* who are seated on the haywains. Armed with shears they must cut the crania of all the bakers who are hammer-throwing on the greens.

<div align="right">RENAUD</div>

OTHER WAYS OF MAKING TEXTS

To make a Dadaist poem

Take a newspaper.

Take a pair of scissors.

Choose an article as long as you are planning to make your poem.

Cut out the article.

Then cut out each of the words that make up this article and put them in a bag.

Shake it gently.

Then take out the scraps one after the other in the order in which they left the bag.

Copy conscientiously.

The poem will be like you.

And here you are a writer, infinitely original and endowed with a sensibility that is charming though beyond the understanding of the vulgar.

TRISTAN TZARA

by Workers of the American Type Foundry

French Clarendon Extra Cond No 10

72 POINT 4 A 6 a $8 23

Anarchist WRESTLES

60 POINT 4 A 6 a $6 71

EUROPEANS Demonstrate

48 POINT 6 A 8 a $5 70

Graduating SCHOLARS Prompted

42 POINT 6 A 12 a $4 28

Auspiciously Decorated TURKISH BUILDINGS

36 POINT 10 A 14 a $4 92

GEOGRAPHICAL SURVEYOR Contemplates Disturbance

24 POINT 12 A 18 a $3 49

Newspaper Publishing Interesting FINANCIAL TELEGRAPHIC REPORTS

18 POINT 16 A 24 a $3 07 12 POINT 20 A 32 a $2 91

DETERMINED POLICEMEN EXHAUSTED SOLDIERS RETURN

Caught Notorious Burglars Plundering Numerous Hardships are Encountered Abroad

1234567890 1234567890

Found poem

37

L'Amour d'abord

Tout pourrait s'arranger si bien

PARIS EST UN GRAND VILLAGE

Surveillez

Le feu qui couve

LA PRIÈRE

Du beau temps

Sachez que

Les rayons ultra-violets

ont terminé leur tâche

Courte et bonne

LE PREMIER JOURNAL BLANC

DU HASARD

Le rouge sera

Le chanteur errant

OU EST-IL ?

dans la mémoire

dans sa maison

au bal des Ardents

Je fais

en dansant

Ce qu'on a fait, ce qu'on va faire

ANDRÉ BRETON, Poem, 1924

TO MAKE A SURREALIST STORY

Take a newspaper, magazine or book: cut and paste at will.

This story was assembled from the London Evening Standard *of 6th June, 1936.*

FINAL NIGHT OF THE BATH

Over two thousand people had taken tickets for this season's murder. Indian incense perfumed the room where people sat at ten round tables decorated with mauve and yellow irises, and were offered the choice of a succession of appetising meals and boiling bathwater up to 2 am. One cutlet was handed to the guest; this was a Zouave, extremely susceptible to drought and other scares. He went away and called out:

'Alice, when you have done put the lights out; the argument against a high rate is the tendency to rush forward which, in the case of big men, ends in cracking; remember that my legs were exceedingly long and my hair is outlined with electric light for the occasion.'

His wife, a debutante this year, asked for a hot bath, which Miss Blatch, the landlady, prepared for her in the bathroom, upon which the searchlights beat, uniforms marched, trumpets and drums and bugles played, and caparisoned horses cantered.

'I do hope I shall not have to wait long,' she said; 'I could take the crown back to England: a murderer is composing an opera for the Coronation which deals with members of the Royal Family, Ministers of State, representatives of the Church and members of the Opposition. They make their entry, as they did to this vale of sorrow, one at a time, astounding the doctor, devastating the father, and astonishing the whole world. It ends with a riotous shooting match and seals the friendship of English-speaking peoples.'

She returned and a little later went upstairs, to disappear into the smoke and the dim curtain of the approaching battle.

The King gave his opinion frankly. 'I think she has a very good chance,' he said; 'It was only a few minutes after I heard the last sound in the bathroom that I heard the organ playing. We did not think she

seriously meant to go swimming because the water was so cold.'

A little later, according to reports from Batavia, she was dead.

The body was left lying on the pavement of Downing Street and was damaging to Mr Baldwin's reputation. When they saw it Sir Samuel's friends said that the assassination was a dastardly deed.

The inquest was held next day and a verdict of accidental death was returned.

Now Mr Baldwin has taken the body back into the Cabinet Room; it contains an exhortation to read 'The Daily Worker' and a form for joining the Communist Party.

ROGER ROUGHTON

THE METHOD OF
RAYMOND ROUSSEL

This method of writing stories was invented by Raymond Roussel. Choose a number of words that have double meanings. Join them together until you have a phrase which makes some sort of sense. This phrase will have at least two distinct meanings. Your task is now to write a narrative in which the phrase constitutes the first and last words of the narrative. Roussel allowed himself to alter a single letter in one of the words chosen. (In the example, prune *becomes* brune.*)*

THE GREENISH SKIN

The greenish skin of the ripening plum [*La peau verdâtre de la prune un peu mûre . . .*] looked as appetising as anyone might wish. I therefore chose this fruit from amongst the various delicacies made ready on a silver platter for the señora's return.

With the point of a knife I made an imperceptible hole in the delicate peel and, taking a phial from my pocket, I poured in several drops of a quick-working poison.

'You betrayed me, Natte,' I said in an expressionless voice. 'Now meet your fate.'

And I replaced the fatal fruit.

I was stifling in my picador's costume, my wig and the great hat. The drawing-room chandeliers rivalled the footlights in brilliance, dazzling me. The doors were loaded with black garments, and across the rows of gilded chairs, low-necked, glittering evening-gowns were strewn. This great Spanish lady lacked for nothing. Suddenly, the sound of sleigh-bells and the crack of a whip from the wings indicated Natte's return.

I quickly seized my voluminous cape, cast over a chair on my entrance, and sprang upon the bed, whose closely drawn curtains permitted me to watch without being seen.

Natte appeared, the lady of the house in person. Still beautiful despite her forty-six years, thanks to artificial means, in particular, to the miraculous dye she employed to preserve the brilliant and intense blackness of her hair. Her features, however, were unfortunately beginning to fade a little, and make-up could not conceal a number of wrinkles at the corners of her eyes and mouth.

Little Madame Dé, charming as an Andalusian *soubrette,* had also entered. Dismissed by Natte after a brief exchange, she departed with her mistress's cloak. Left alone, Natte sat down to her supper.

'Turquoise, O Turquoise, how I love you!' she exclaimed, her voice trembling.

Turquoise was a young muleteer with whom Natte was deceiving me. An intercepted letter, telling all, had impelled me to murder.

'How sweet is the thought of you, Turquoise, O my young lover!' said Natte again, her gaze dreamily unfixed.

Then rising in agitation:

'Lord God, if Mirliton knew – he'd kill me!'

Mirliton, I am he, the abandoned picador. To dispel her fears, Natte began to eat. The Spanish type to perfection, she had two beauty spots, one on her chin, one on her cheek, and her magnificent black hair, reflecting the stage lights, obliterated all thought of her ageing features.

'What is Turquoise doing at this moment?' she murmured, between a piece of layered cake and a small tart. 'He is thinking of me, as I of him'.

From my observation post, I attentively watched her supper diminish. Natte sought to calm herself.

'Mirliton knows nothing, he loves me, trusts me absolutely . . .'

She had just finished an apricot; nothing but the fatal fruit remained. She took it between two fingers.

'What if Mirliton knew,' she continued in a hollow voice.

Then she bit . . .

The effect was instantaneous. She rose to open a window, as if suffocating, turned about several times beating the air with her arms and fell dead upon the carpet.

I was on the floor with a single bound and ran to extinguish the candles burning in two silver candlesticks on the table. At once all the lights went down, the chandeliers and footlights as well. A single broad beam of moonlight shone through the open window upon the corpse.

I took my cape from the bed, the great black cape in which I was accustomed to envelop myself, and completely covered Natte's body. Then I knelt beside her in silence.

Motionless, she was as of marble. The black cape covered her entirely. The head alone was visible, its black hair gleaming, the ageing face amidst dazzling hair, pallid beneath the moonlight which poured, almost greenish, through the window.

The effect was tragic.

One thing was visible, only one . . .

The sallow complexion of the brunette past her prime . . .

[*La peau verdâtre de la brune un peu mûre . . .*]

RAYMOND ROUSSEL

DIRECTIONS FOR USE

Using the style and format of the Directions *to be found on the labels of household products, D.I.Y. kits and other ordinary items, apply them to items that do not require such instructions. The following examples are all by Jean-Claude Silbermann.*

THE HEART

To retain its perfect freshness, keep **THE HEART** dry. UNLIKE similar products, **THE HEART** WILL EXPAND WHILE DRYING OUT. All actions performed with **THE HEART** are therefore definitive.

PREPARATION OF SENTIMENTS: To one measure of delirium, add 2½ measures of **HEART**. Stir until a sentimental solution forms. Allow to stand for one night. While you sleep, the sentiment will take on the desired consistency (creamy, oily or malleable). Do not prepare more **HEART** than you can use immediately, since even in a short space of time it tends to cling.

IMPORTANT: **THE HEART** acts like a cement, so delirium must never be added to previously prepared sentiment, nor should it be 'dwelt on' too long. **THE HEART** hardens in two hours. Increase the dosage of **HEART** in the first few seconds if you desire a sentiment with a firmer consistency.

THE HEART casts a self-satisfied glow over generous and kind individuals.

When applied to meaner personalities however (*especially if allowed to penetrate the whole being*) it tends to be dissipated throughout the pores and becomes totally transparent.

THE GREAT MYSTERY

DIRECTIONS:

For Middle-aged or Young Novices

With the addition of platitudes, apply THE GREAT MYSTERY, ensuring the spirit is well steeped in it, and store away in a dark place.

Leave the novice for at least twenty or thirty years to dry out, or until all his opinions are fully blackened. His spirit should then be a mottled grey colour. If whitish marks appear, due to an excess of salt, it is possible to remove them by rubbing lightly with whatever comes to mind. If lumps appear, brush to revive and make a second local application.

The novice is then in a position to begin speechifying, employing all the words customarily used for external purposes. Instead of speaking directly he can use a protective screen. Our screen (colourless or black) may be used indefinitely.

WARNING Stains resulting from THE GREAT MYSTERY coming into contact with daily life must be removed immediately with running water.

For Elderly novices a preliminary scrub with the wire-brush of cynicism is necessary to remove scales and as many prejudices as possible.

DEATH

Its combination of instantaneous and eternal action
ensures that DEATH is absolutely harmless to man or
mammals.

DEATH DOES NOT STAIN

DIRECTIONS

Remove the self-preserving seal, hold DEATH verti-
cally, valve upwards, and apply by pressing the stopper.

For heart complaints: Use DEATH centre-stage. A few
seconds only is sufficient.

For gambling debts, dishonour, tedium vitae etc.: Apply
DEATH liberally around the edges of the room, near
skirting-boards, in cracks in the floor, in any dark
cranny. Repeat every four to five hours.

For mystical ecstasy: Use DEATH having placed
yourself approximately one metre from clothing,
curtains, carpets.

DEATH can be used in wardrobes and wall-cupboards.
Shut them immediately after each application.

DEATH is recommended in Spring, from April onwards.
DEATH IS GOOD FOR YOU.
NON-TOXIC.

VISUAL TECHNIQUES

It is not to be despised, in my opinion, if, after gazing fixedly at a spot on the wall, coals in the grate, clouds, a flowing stream, if one remembers some of their aspects; and if you look at them carefully you will discover some quite admissable inventions. Of these the genius of the painter may take full advantage, to compose battles of men and animals, landscapes or monsters, devils and other fantastic things . . .

LEONARDO DA VINCI (Treatise on Painting)

How to Open at Will the Window onto the Most Beautiful Landscapes in the World and Elsewhere.

ANDRÉ BRETON (on Decalcomania)

THE PURPOSE OF SURREALIST VISUAL TECHNIQUES IS TO OPEN A WINDOW ONTO THE MARVELLOUS THAT LIES CONCEALED BEHIND THE EVERYDAY. THIS REVELATION CAN BE ACHIEVED BY DIFFERENT MEANS: BY MANIPULATING MATERIALS, OR BY PLAY WITH IMAGES, WHETHER GIVEN OR FOUND.

THE FIRST CATEGORY OF TECHNIQUES INCLUDES THOSE THAT ARE ESSENTIALLY AUTOMATIC; THESE 'FREEZE' CHANCE EVENTS IN WHATEVER MEDIUM IS BEING USED, TO CREATE ARTIFICIALLY LEONARDO'S 'BLOTS' AND 'CLOUDS', AND IN THIS WAY THEY PROVOKE SPONTANEOUS IMAGES FREE OF CONSCIOUS INTENTION. ONCE THESE IMAGES APPEAR THEY CAN BE ELABORATED; IN MARCEL JEAN'S WORDS, THEY PROVIDE 'THE POINT OF DEPARTURE FOR POETIC HALLUCINATION'.

INTO THE SECOND CATEGORY FALL VARIOUS METHODS OF DIRECTLY RE-INTERPRETING EXISTING IMAGES TO PRODUCE NEW, MORE PROVOCATIVE OR BEAUTIFUL VISIONS, DELIRIOUS AND MONSTROUS AMALGAMATIONS.

MANIPULATING CHANCE

AUTOMATIC DRAWING

As with automatic writing, put yourself in a receptive frame of mind, draw without thinking, and avoid conscious control over the image. Keeping your pencil on the paper can help the flow.

In fact, automatic drawing is a sort of accelerated or intensified doodling, in which unexpected and unpredictable images can be made to appear, and used as the basis for further visual play.

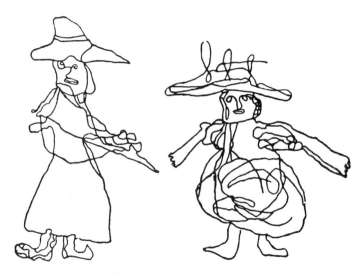

MADAME SMEAD, Martian Man and Woman

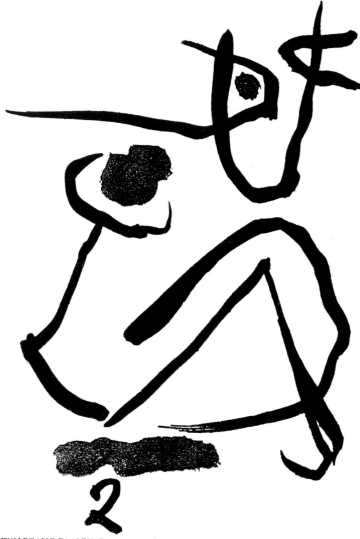

WOLFGANG PAALEN, Drawing, 1954

50

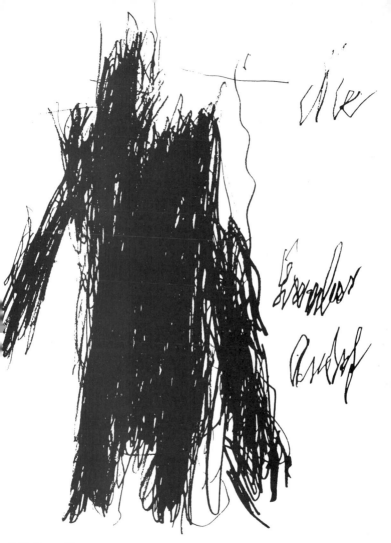

MAX, Human Figure

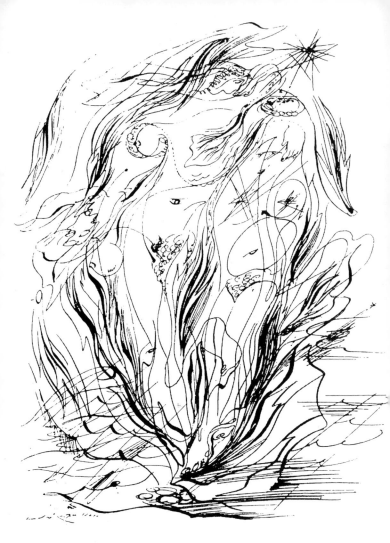

ANDRE MASSON, The Lovers, 1924

52

FUMAGE

A method of creating images or effects by passing paper or canvas over a smoking candle or petroleum lamp. The image is then fixed and perhaps worked on.

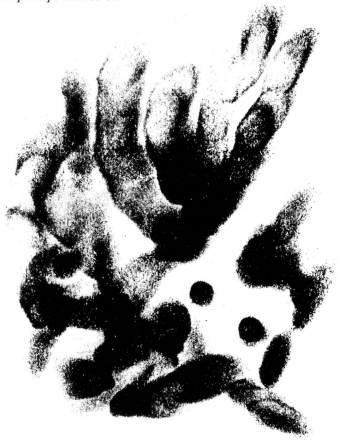

WOLFGANG PAALEN, Untitled, 1938

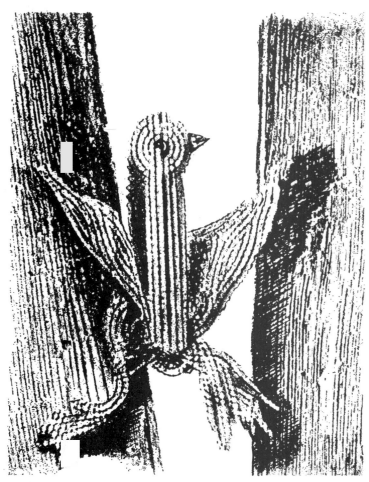

MAX ERNST, Frottage

FROTTAGE

This is the same technique as that of brass-rubbing. A sheet of paper is placed on any natural or manufactured surface possessing a relief or incised pattern. The paper is rubbed with crayon, a soft pencil, charcoal, etc. By combining frottages *from different surfaces complex effects can be achieved within one drawing. The pattern or image obtained can be coloured, cut up, or combined with other materials in* collage.

DECALCOMANIA
(WITH NO PRECONCEIVED OBJECT)

Spread gouache, ink or oil paint, diluted in some places, on to any suitable non-absorbent surface (coated paper, glass, etc.) press on to this, your sheet of paper or canvas, then lift or peel away.

Decalcomania is related to other games and procedures that resemble the celebrated Rohrschach Test used by psychologists, in which an ink-blot is folded in two to create a roughly symmetrical image. The parlour game equivalent is called GHOSTS OF MY FRIENDS, in which players' signatures are folded in two while still wet. The resulting image is interpreted for revelations about the signatory.

A variation of decalcomania is écrémage, *a form of 'marbling'. In this, an image is drawn into an oily liquid with a water-based pigment (or vice versa). A sheet of paper is then placed upon or made to slide across this surface, and the image lifted or 'creamed' off the liquid.*

MARCEL JEAN

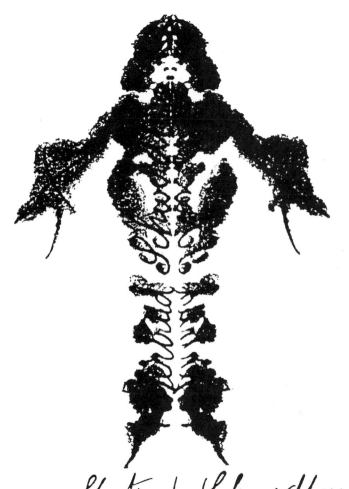

Name *Gertrud Schwerdtner*

HANS ARP, Torn Paper, 1932

TORN PAPER COLLAGE
(ACCORDING TO THE RULES OF CHANCE)

This form of collage was invented by Hans Arp.

Paper is torn or cut up, randomly or in shapes, and the pieces dropped on to a sheet of paper. These random configurations are then fixed with glue.

In a variation of this technique, the torn paper already bears an image, which is thus dislocated and re-assembled unpredictably according to the fall of the paper. It can then be 're-interpreted' by subsequent working over with pencil or brush.

SOME OTHER AUTOMATIC TECHNIQUES

GRATTAGE
The process of scraping wet or dried paint (or a mixture of both) from a canvas or other surface with a blade.

SAND PAINTING
Glue is first randomly smeared on the canvas, then sand sprinkled upon it. It may be left to dry as it falls, or further manipulated with brushes, knives etc.

FROISSAGE
A sheet of paper is screwed up, then smoothed out again. When soaked in coloured inks, the creases take up the colour, creating a veined effect.

COULAGE
A variety of three-dimensional decalcomania created by pouring molten metal (usually lead) or other molten materials such as wax or chocolate into water. The material solidifies into fantastic shapes.

RE-ASSEMBLING REALITY

COLLAGE
Collage, sticking together cut-out images, takes various forms within the scope of this book.

'SURREALIST COLLAGE'
Max Ernst invented this method of pasting together fragments of given or found pictures. By using images that already had a similar 'look' (principally engravings illustrating novels, magazines and technical or commercial publications) he was able to create 'illusionistic' new pictures—bizarre, fantastic, dream-like, ironic or grotesque.

MAX ERNST

MAX ERNST, *Open Your Bag, My Good Man*

ALAIN JOUBERT, Freud Discovers the Libido

JINDRICH STYRSKY, Baby Jesus, 1941

PHOTOMONTAGE

A variation of collage using photographs. Retouching and re-photographing the image can produce a more unified image.

INIMAGE

In this reversal of the two collage techniques above, sections are cut away from an already existing image in order to create a new one.

R. PASSERON, Inimage, 1965

TEXT MONTAGE

Printed texts are taken from different sources and combined for different purposes.

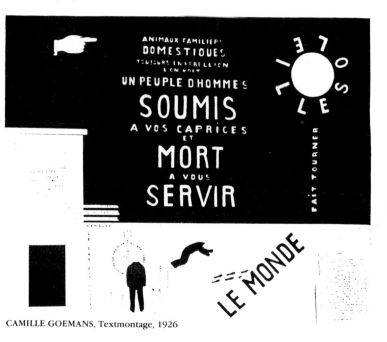

CAMILLE GOEMANS, Textmontage, 1926

Surrealist collage was anticipated by WHAT A LIFE (1911), a book greatly enjoyed by the Surrealists.

UNION IS STRENGTH

ILLUSTRATED BY WHITELEY'S

Ponto, the watch dog, seemed dazed. **He** had been drugged, the detective said.

He also pointed out that the horse's neck was strangely swollen.

It was Lord Crewett who won the Derby with "Salad Days."

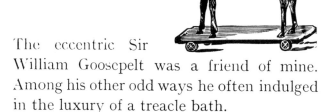

The eccentric Sir William Goosepelt was a friend of mine. Among his other odd ways he often indulged in the luxury of a treacle bath.

Sir William's ears were so large that he required a chin-strap to keep his hat on. From this circumstance he earned an unenviable reputation for impoliteness towards ladies.

His wife, dear Lady Goosepelt, was a chronic invalid, and lived at Bournemouth in a charming *villegiatura*.

THE PARANOIAC-CRITICAL
METHOD

The Paranoiac-critical method was the invention of Salvador Dali and is an extension of the method of Simulation into the field of visual play, based on the idea of the 'double-image'.

According to Dali, by simulating paranoia one can systematically undermine one's rational view of the world, which becomes continually subjected to associative transformations. 'For instance, one can see, or persuade others to see, all sorts of shapes in a cloud: a horse, a human body, a dragon, a face, a palace, and so on. Any prospect or object of the physical world can be treated in this manner, from which the proposed conclusion is that it is impossible to concede any value whatsoever to immediate reality, since it may represent or mean anything at all.' (Marcel Jean) The point is to persuade oneself or others of the authenticity of these transformations in such a way that the 'real' world from which they arise loses its validity. The mad logic of Dali's method leads to a world seen in continuous flux, as in his paintings of the 1930s, in which objects dissolve from one state into another, solid things become transparent, and things of no substance assume form.

The Paranoiac-critical method is thus the reverse of the children's 'picture-puzzles' in which people are hidden in drawings of trees etc., and resembles more the 'double-images' employed by psychologists: the two faces that become a vase, and other similar illusions such as faces seen in rocks, landscapes in marble and the anthropomorphic forms of plants such as the mandrake root.

None is perhaps so striking as the face discovered by Dali in the photograph opposite, whose true orientation is indicated.

THIS WAY UP ☞

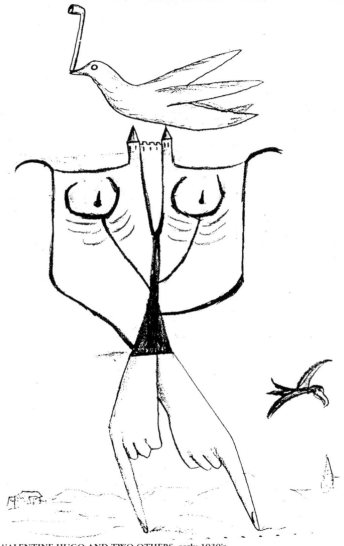

VALENTINE HUGO AND TWO OTHERS, early 1930's

THE EXQUISITE CORPSE

For three or more players.

This, the most celebrated Surrealist game of all, is based on the same principle as that of the written 'exquisite corpse'. Its parlour game equivalent is Heads, Bodies and Legs *in English and* Petits Papiers *in France.*

Each player receives a sheet of paper and folds it into equal sections, as many as there are players, and usually with the lines horizontal to the proposed picture. The sheets are smoothed out and each player draws whatever he will in the top section, allowing the lines to cross the crease by a few millimetres. The sheet is then refolded back onto this crease to conceal the drawing and passed to the next player who begins the next section from these lines. And so on, until the last section, when it is unfolded and the result revealed.

(The sheet may be passed back for the first player to furnish it with a title before the picture is revealed.)

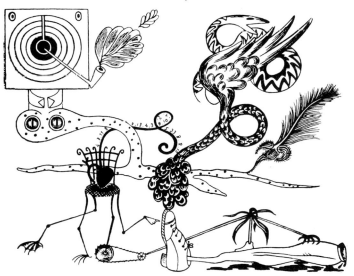

GRETA KNUTSON, VALENTINE HUGO, ANDRÉ BRETON, TRISTAN TZARA, 1936

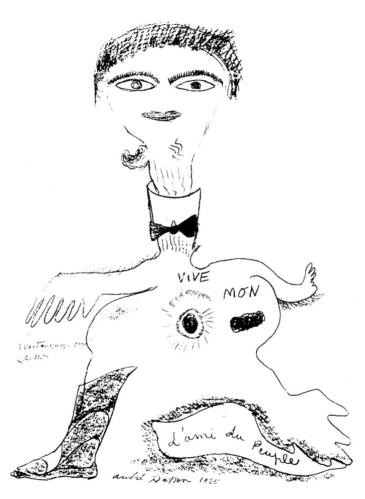

Text within the image: VIVE MON / L'ami du Peuple / andré Masson 1925

YVES TANGUY, ANDRÉ MASSON AND TWO OTHERS, 1925

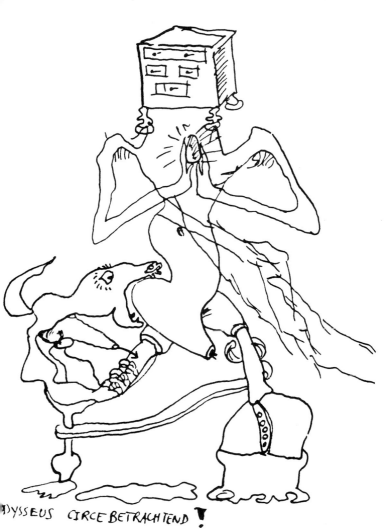

DYSSEUS CIRCE BETRACHTEND !

LILO KLAPHECK, JOSEPH BEUYS, KONRAD KLAPHECK, EVA BEUYS,
Odysseus Scrutinising Circe, 1970

HUDECECK, GROSS,
BARTOVSKY, CHALUPECKY, 1934

JACQUELINE LAMBA, ANDRÉ BRETON, YVES TANGUY, 1938

In Menzldjémil (Tunisia), Mme Chassous, a commandant's wife, would have been assassinated had her corset not stopped the blade.

A hay barn at the barracks of the 7th Hussars at Niort went up in flames. All the soldiers bar one, who is now in hospital, got out in time.

HEISLER AND PÉRET, Potato Cuts

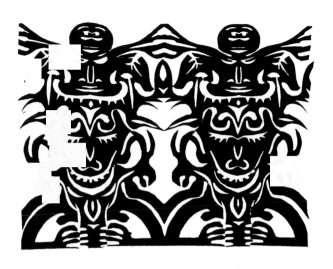

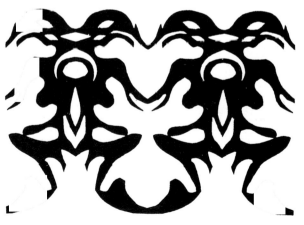

ANDRÉ BRETON, Folded Paper-Cuts

RE-INVENTING THE WORLD

Transform the world, said Marx; change life, said Rimbaud: for us these two watchwords are one.

ANDRÉ BRETON

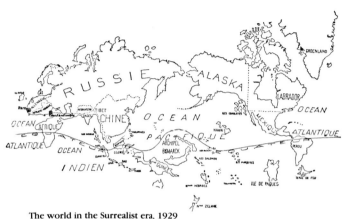

The world in the Surrealist era, 1929

THE GAMES AND PROCEDURES IN THIS SECTION ARE IN THE SPIRIT OF BRETON'S 'WATCHWORDS'. THEY AIM TO TRANSFORM AND REVALUE THE CATEGORIES INTO WHICH WE HABITUALLY ORDER THE FAMILIAR WORLD, AND SUBSTITUTE A SURREALIST VIEWPOINT FOR THE CONVENTIONAL ONE. METHODS OF INTERPRETATION AND ALTERATION, THEY TAKE A NUMBER OF FORMS: 'INQUIRIES' OR QUESTIONNAIRES; EXPERIMENTS WITH REAL OR IMAGINED OBJECTS; OUTRIGHT PROVOCATIONS; IRONIC OR FANTASTIC PLAY WITH CONVENTIONS OF DEFINITION AND CLASSIFICATION AS FOUND IN DICTIONARIES, BIBLIOGRAPHIES AND ENCYCLOPEDIAS; COMIC SUBVERSIONS OF FOLK WISDOM (PROVERBS, SUPERSTITIONS); NEW VERSIONS OF EXISTING GAMES.

INQUIRIES

*Many Surrealist games depend on questions and answers, where the inquiry is intended to throw up the unexpected, and also reveal unsuspected and perhaps fundamental information about the persons responding. Surrealism, in a number of these procedures, pushes the inquiry to the point of **inquisition**, which can make these games extremely uncomfortable experiences.*

'THOUGHT FOR THE DAY'

Are you ready to assist in the escape of a convicted criminal, regardless of his crime?

Would you welcome the complete disappearance of night? Or of day?

How would the certainty of the human race's annihilation in the comparatively near future transform your conception of life?

Have you had the experience of re-entering a dream at the point where it left off, one or more days before?

How is it that taking a knife to bisect an apple so frequently ends in a distribution similar to that of a queue, which seems so unlikely *a priori?*

'Can one modify man?' asks Jean Rostand. Does a modification of our equipment seem to you useful? Desirable? Suggestions please.

If you had the opportunity to change sex at regular intervals, e.g. one day in seven, would you accept? Then what would you do?

Death: Male or Female?

WOULD YOU OPEN THE DOOR?

For five or more players, each with pencil and paper.

Players are asked to imagine this situation: they are dreaming, there is a knock at the door, they open it and, recognising the visitor, they must make an immediate decision to either let the visitor in or close the door. What do they decide and why?

Each player takes it in turn to announce the visitor's name, and the others write either yes *or* no, *plus a brief comment which must be the first thing that occurs to them. The visitor may be famous, infamous, living or dead; or perhaps someone known to all the players. Results are read out and compared.*

(The identity of the players in the game in the example, and of those in the games that follow, is given by initials, a key to which will be found on p. 139.)

CÉZANNE

No, consigned to the textbooks. [J-L B] Yes, through wanting to get it over with. [R B] No, nothing to say to each other. [A B] No, too caught up in his theories. [E B] No, seen too much of him! [A D] No, so dreary! [G G] Yes, suppose so, but conversation might well wear a bit thin. [J G] No, boring. [G L] No, urge to laugh. [S H] No, I'm afraid his intentions prejudice his painting. [W P] No, too stupid. [B P] No, I have my window. [J P] No, no time to waste. [B R] No, hate apples [J S] No, since I love apples. [A S] No, enough of still lifes. [T] No, I like fruit too much. [M Z]

MARX

Yes, coolly. [J-L B] Yes, out of obligation. [R B] No, from weariness. [A B] Yes, but in silence. [E B] Yes, we have an old bone to pick even so. [A D] Yes, through exhaustion. [G G] No, gloomy evening predicted [J G] No, really too separate from his contribution, in my view. [G L] Yes, to offer him a little red wine [S H] No, his doctrine spawned the most oppressive religion. [W P] Yes, greetings comrade! [B P] Yes, I was expecting you. [J P] No, with apologies. [B R] Yes, to ask him the question 'How far's he got with time?' [J S] No, we'd bore each other. [A S] Yes, very warmly. [T] Yes, how are you? [M Z]

SCOREBOARD, OR SCHOLARLY NOTATION

For any number of people, as many as practicable.

The participants draw up a list of people, objects or ideas to be considered. Each player gives them marks on a scale from +20 to −20. (+20 = unreserved approval, 0 = utter indifference, −20 = total abomination.) The marks are collected and tabulated as below.

	GRD	TT	BP	AB	JR	LA	TF	CP	PS
Talent	−20	−15	0	−10	1	0	5	−17	−19
Desire	15	−6	20	20	20	20	−20	10	−3
Civilisation	−20	−3	−15	−20	0	0	−20	−1	12
Strength	0	4	0	0	11	0	14	−20	19
Weakness	−1	−4	−10	−17	−5	−1	14	0	15
Imagination	19	13	18	19	11	12	0	1	12
Suicide	−20	19	14	−19	19	19	−18	15	−20
France	−10	1	0	−19	0	−20	20	5	14
England	−19	−3	−10	−20	0	1	20	2	11
Germany	7	−11	14	11	0	6	20	2	10
19th Century	0	−17	3	6	−11	0	−18	−2	0
Nature	0	12	−20	−1	−20	0	0	−20	
Poetry	20	0	18	19	5	16	−18	20	
The Present	0	19	0	20	5	7	0	20	
Madness	19	8	19	4	15	−20	−15	15	13
Happiness	−20	−18	−15	−20	0	0	−15	2	20
Logic	−19	−20	−19	−1	−11	−20	18	−19	−20
Causality	−19	−19	0	0	0	−20	−10	−15	−18
Dream	14	7	18	20	18	20	−2	0	
Chance	18	19	20	20	20	20	16	20	19½
Love of money	0	−17	15	−19	20	0		−5	
Honesty	0	0	−10	−20	0	−20		0	
Family		−20	−20	−20	−20	−20		−20	
Clergy		−20	−20	−20	−20	−20		−20	
Humour		2	19	20	15			17	

	A	S	B	E	T
Aragon	8	-2	-15	20	10
Breton	3	14	8	2	15
Eluard	1	7	-10	4	7
Frankel	12	-10	-18	-5	6
Ribemont	0	-9	0	15	12
Péret	-10	-1	1	6	4
Soupault	8		18	-15	14
Tzara	9	19	18	9	
Picabia	7	19	16	-13	15
Duchamp	11	17	16	-20	17
Rigaut	3	8	-5	16	18

$$A \frac{13}{4} = 3, \frac{1}{4} \qquad \text{Rib. } 3, 60$$

Breton = 8 ½ Piret 0.

Eluard 1 ¼ Soupault 6 ¼

Frankel 1 4 ¼ Tzara 10, ½

Picab 8, ¾

Duch 8 ¼

Rig. 6 ½

The example of this game on the previous page is a much reduced version of a game played in the early 1920s. This particular session ended with the following table, in which players assessed each other. The line of initials at the top indicates: Aragon, Soupault, Breton, Eluard, Tzara; and the calculations at the bottom give the average scores achieved.

ANALOGY CARDS

As large a group of players as possible.

This game is a more complex version of the game of 'Portraits', in which one player assumes the identity of a famous person and the others must guess who it is by asking questions such as: 'What mineral are you?' or 'What animal are you?' In Analogy Cards *the situation is reversed: the identity of the person is known, having been chosen before the game begins. The aim of the game is to arrive at a portrait of this chosen person based on the categories which feature on passports or identity cards. These categories, which describe the person's attributes, are given in the form of various animals, objects etc.*

The categories of the card, and the equivalent objects or events into which they are to be translated, are a constant of the game. They consist of the following:

PHOTOGRAPH: *an animal.*
FATHER AND MOTHER: *born of the union of.*
PLACE OF BIRTH: *a geographical location.*
DATE OF BIRTH: *an historical event.*
NATIONALITY: *a civilisation or culture.*
PROFESSION: *pastime.*
DOMICILE: *a painting.*
HEIGHT: *a vegetable.*
HAIR: *a colour*
APPEARANCE: *a romantic or legendary hero.*
EYES: *a mineral.*
COMPLEXION: *a meteorological phenomenon.*
NOSE: *a perfume.*
VOICE: *a poem.*
DISTINGUISHING CHARACTERISTICS: *sexual preference.*
CHANGE OF ADDRESS: *means of transport.*
RELIGION: *conception of the world.*
FINGERPRINT: *unique signature.*

The person to be described may be famous, infamous, contemporary or historical, but must be well known to all the players. (Players of the game, or their acquaintances, may be chosen.) Each player composes his own set of equivalents before the game begins. During the game these are read out, and after discussion and explanations, one is agreed upon by a vote, as definitive. The various differences and agreements are analysed during the session.

SIGMUND FREUD

PHOTOGRAPH: Star-nosed mole.
FATHER AND MOTHER: Day and night.
DATE OF BIRTH: 2 December 1814, 10pm.
PLACE OF BIRTH: Gizeh, at the foot of the Sphinx.
NATIONALITY: Siberian (Paleoarctic Circle).
PROFESSION: Snakes and ladders.
DOMICILE: The Scream, by Edvard Munch.
HEIGHT: Banyan fig.
HAIR: Ultramarine.
APPEARANCE: Jason.
EYES: Magnetized Iron.
COMPLEXION: Midnight Sun.
NOSE: Ozone.
VOICE: Games of mother and child, by Xavier Forneret.
DISTINGUISHING CHARACTERISTICS: Rape.
CHANGE OF ADDRESS: Raft of the Medusa.
RELIGION: Breakdown of frontiers.
FINGERPRINT: Set of scales weighing its own arm.

THE TRUTH GAME

For any number of players.

One player questions each of the other players in turn; alternatively, each player questions one player in turn. The answers must be the truth. The game should be played for some time to achieve meaningful results.

N.B. The questions, as well as the replies, are to be considered as symptomatic.

The examples which follow are very brief extracts from an extensive RESEARCH INTO SEXUALITY, *the nearest approximation to a published version of the* TRUTH GAME.

BRETON: A fanciful question: suppose Péret saw in a café, reunited, every woman with whom he has been sexually involved, and the one he loves or thinks he loves, standing there on her own. What would he do?

PÉRET: Bewildered retreat.

BRETON: Aragon?

ARAGON: I hope I'd muster the necessary presence of mind to get the one I loved out of the wretched place.

BRETON: Noll?

NOLL: This could only happen in a nightmare. I'd leave the café with a person who wasn't necessarily the one I'd have liked.

ARAGON: Breton?

BRETON: I think I'd deliver a long speech. The conclusion of the speech would be . . . [*An absolute tangle of erasures follow these dots in the written record!*]

Another topic:

ELUARD: How do you reconcile your love of women and your taste for sodomy?

TANGUY: Sodomy is not homosexual. It interests me only when performed with a woman, not for any other reason.

BRETON: The question of reconciliation does not arise. I prefer sodomy for moral reasons and above all through considerations of non-conformity. No chance of a child with a woman one does not love, and that a woman one does love can so abandon herself seems to me infinitely arousing.

ELUARD: Why?

BRETON: From the materialist point of view, in the case of a woman I love, it is infinitely more pessimistic (shit's law) and therefore more poetic.

ELUARD: But why, for example, does not the idea of conception through coitus appear more pessimistic to you than shit?

BRETON: Because it is in conformity with growth which is mingled in my mind with the idea of well-being.

ELUARD: For me, two beings at the moment of coitus, represent an end in themselves and reproduction is an evil.

BRETON: That is a completely Christian idea of the problem.

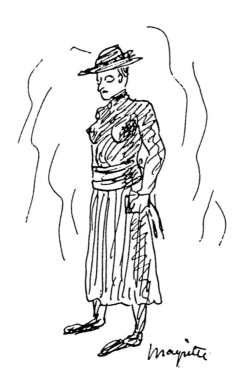

RÉNE MAGRITTE, The Puritan

And climactically:

ALBERT VALENTIN: What do you say at the moment of orgasm?
PIERRE UNIK: The most I have ever said was 'Ha!'
SIMONE VION: I don't say anything.
RAYMOND MICHELET: Nor I.
ANDRÉ BRETON: Nothing.
ANDRÉ THIRION: I think I once said 'Darling'.
HUMM: [Complete silence.]
VICTOR MEYER: Nothing.
PIERRE BLUM: With someone I love 'Darling', otherwise nothing.
MADAME LENA: Generally I say 'Fernande' (that's my sister) or 'Denis' (he's a doctor I am in love with but I have never slept with him), or 'Pierre'.
SCHNITZLER: Nothing.
SCHWARTZ: 'My dearest' or 'My Lulu'.
KATIA THIRION: 'I love you (a.i.o. . . .)' [The record does not indicate the meaning of this.]
ALBERT VALENTIN: 'Slut', 'Scum', 'Tart' etc.
PAUL ELUARD: I never stop talking.

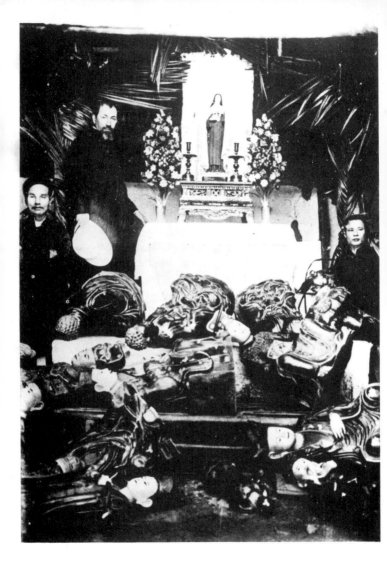

PROVOCATIONS

RELIGION

Our revolution will never succeed until we have eradicated the myth of God from the mind of man.

<div align="right">LENIN</div>

You say that you believe in the necessity of religion. Be honest! You believe in the necessity of the police.

<div align="right">NIETZSCHE</div>

All religions lend despotism a hand: but I know none that does so more than Christianity.

<div align="right">MARAT</div>

A man must be very lacking in any moral sense if he needs religion to make a gentleman of him.

<div align="right">NINON DE LENCLOS</div>

Christianity is religion *par excellence,* because it completely exposes and manifests the nature, the absolute essence, of all religious systems — that it involves the impoverishment, subservience and abasement of man for the benefit of divinity.

<div align="right">BAKUNIN</div>

Priest: (n) — one who controls our spiritual affairs in order to improve his temporal affairs.

<div align="right">AMBROSE BIERCE</div>

The Priest and the Tyrant share the same policy and the same interests. All either one of them needs is imbecilic and craven subjects. Both are corrupted by absolute power, licence and impunity. Both corrupt — one in order to rule, the other to expiate. They come together to snuff out the light, to crush reason and drive the desire for liberty out of the very hearts of men.

<div align="right">D'HOLBACH</div>

LEFT: Missionary converting a Buddhist temple into a church, Vietnam 1935

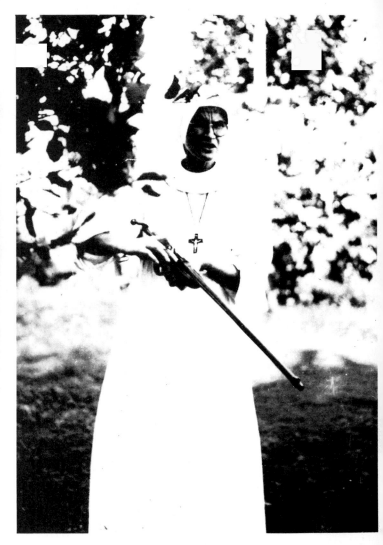

Benjamin Péret in the act of insulting a priest

He who sleeps with the Pope requires long feet.

If you see a priest being beaten, make a wish.

*For good luck, nail up consecrated hosts
in the bathroom.*

*When passing a cemetery, throw some rubbish
over the wall, this brings good luck.*

*In the autumn, light the first fire in the hearth with
a crucifix, this brings good fortune.*

BENJAMIN PÉRET

IDIOT

Good patriots are idiots; good patriots bugger the country.

> *Every day, at any time, at least one patriot is shitting on the nation's sacred turf without a second thought.*

Priests are idiots; they know nothing about religion.

> *We shall teach them about it.*

The executioners at Breendonck concentration camp are idiots; they have absolutely no imagination.

> *For instance, they could have made their victims look at themselves in the mirror.*

Reader, you, too, of course, are an idiot.

The cops protect you (badly), but you suffer (badly).

The rest is shit.

Broadside produced by RENÉ MAGRITTE and MARCEL MARIËN

100

Prière du XXᵉ siècle

Blessèd be Thou, O Lord,
For my brother the telephone,
Which liberates me and ceaselessly pursues me,
And sometimes remains silent
When I am waiting on tenterhooks.
A little like your grace, O Lord:
You are the silent God and the God lying in wait.

Blessèd be Thou,
For my brother the thermostat,
The obedient instrument of the atmosphere.
It suggests to me a humble and discreet rôle:
To be the one who sets the tone,
Naturally, by intuition alone,
Giving only what is necessary, nothing more.

Blessèd be Thou,
For my brother the refrigerator,
Which keeps alive my fragile sisters, the vitamins.
Ah! If only I were as careful in conserving life,
As little open to corrupt ideas,
As good at preserving and keeping wholesome
 traditions.

Blessèd be Thou,
For my brother the tape recorder,
Which marks on the tape what I want to hear again.
A little like the conscience you have given me,
And which I alter if I find an error.
The error is recorded and conscience is wiped off.

Blessèd be Thou,
For my four-wheeled sister,
Who is light-hearted and lively,
Who lets me sing at the top of my voice without
 irritating anyone,
Who makes me pray in a new way.

Blessèd be Thou, O Lord,
For the intellect of your child, mankind.

MADELEINE BIQUET-NOLETTE

'Twentieth Century Prayer' from a confessional pamphlet

PARTIES

When invited to a party, unless the contrary is expressly stated, the Guest must assume that he is expected to make love eventually to the Hostess; for a party without love is as a snare without delusions, wrack without ruin, or as rough without a tumble. The Hostess is to be considered as the mistress of the house. If, for any reason, this should be distasteful to the Guest, he must make his attitude clear at the outset. On entering the drawing room, pay your respects immediately to the Hostess, then say,—'I have no intention of sleeping with you tonight.' She will reply with some expression of polite surprise, such as—'Why, Mr X?' The Guest must be prepared to explain why, or more exactly, why not, as truthfully as possible.

PETER LLOYD — *Notebook of Etiquette*

SQUARING THE CIRCLE

ACT I

THE COUNT [*returning from a stroll*] I have mislaid my waterproof.

THE COUNTESS. Good gracious! It's as if we are all in a dream. Are we awake or sleeping? [*Calling the butler.*] Baptiste! Baptiste! [*Enter* BAPTISTE.] Ah! There you are. Tell me, Baptiste, are we awake or dreaming?

BAPTISTE. There is evidence both for and against, my Lady. Rationally, there is no way I can prove that you are not purely a figment of my imagination.

ACT II

THE COUNTESS [*to* THE COUNT]. No, not tonight, I am indisposed.

ACT III

THE COUNT [*to* BAPTISTE]. Although you are not from my social sphere, Baptiste, I feel the need for a physical relationship with you.

BAPTISTE. Very well, Milord. In order to make room for you I must first go for a crap.

<div style="text-align: right">Curtain.</div>

<div style="text-align: right">RENÉ MAGRITTE</div>

OBJECTS

*The object in its Surrealist manifestation is distinguished from others by its radical **change of role**. Wherever it comes from, whether it exists in the objective world, in reverie, or in dreams, it no longer maintains its identity within the banal categories of the ordinary and the everyday. Surrealist experiment and play with the object transforms it and confers upon it the properties of the marvellous.*

Anyone can play.

SOME CATEGORIES OF SURREALIST OBJECTS

OBJECTS SEEN IN DREAMS

. . . Recently I suggested that as far as is feasible one should manufacture some of the articles one meets only in dreams, articles which are as hard to justify on the ground of utility as on that of pleasure. Thus the other night during sleep, I found myself at an open-air market in the neighbourhood of Saint-Malo and came upon a rather unusual book. Its back consisted of a wooden gnome whose white Assyrian beard reached to his feet. Although the statuette was of a normal thickness, there was no difficulty in turning the book's pages of thick black wool. I hastened to buy it, and when I woke up I was sorry not to find it beside me. It would be comparatively easy to manufacture it. I want to have a few articles of the same kind made, as their effect would be distinctly puzzling and disturbing.

ANDRÉ BRETON, 1924

LEFT: The Ideal Palace, built by Cheval, the postman

A glass found after the eruption of Mont Pelé, 1902

NATURAL OBJECTS
Objects from nature conforming to Surrealist ideas of beauty.

PERTURBED OBJECTS
Natural or manufactured objects which have undergone some sort of deformation.

INTERPRETED OBJECTS
Objects given a new meaning by juxtaposition with other objects, or by the negation of their function.

BOOK OBJECTS
The book as fetish, as an object not for reading.

MATHEMATICAL OBJECTS
Objects perturbed by mathematics.

POEM OBJECTS
Poems in which several of the terms are objects instead of words.

ALSO:
Mobile and mute objects, phantom objects, being-objects, incorporated objects, involuntary objects, oneiric objects, ethnological objects etc., etc..

OBJETS MATHÉMATIQUES
OBJETS NATURELS. OBJETS
SAUVAGES. OBJETS TROU-

L'OBJET

VÉS. OBJETS IRRATIONNELS
OBJETS READY MADE. OB-
JETS INTERPRÉTÉS. OBJETS IN-
CORPORÉS. OBJETS MOBILES

From *Cahiers d'Art,* 1936

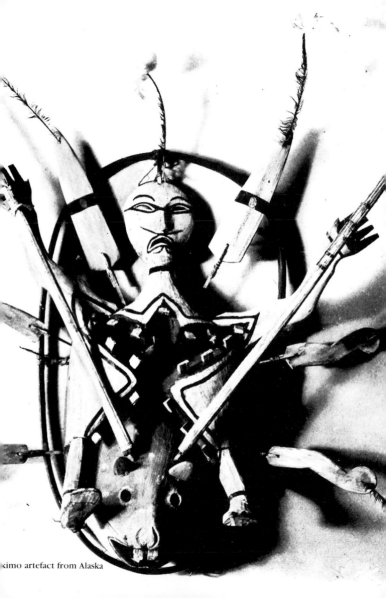

kimo artefact from Alaska

FOUND OBJECTS
Objects which simply have a particular presence, or which seem destined to be found, and whose function must be discovered by the finder.

Objects found in street-markets.

OBJECTS TO FUNCTION SYMBOLICALLY

Objects described by Dali, but made by many Surrealists which symbolise the state of mind and erotic desires of both the maker and the spectator.

Giacometti's object, described by Dali, is certainly the most elegant of these.

A wooden bowl, having a feminine depression is suspended by means of a fine fiddle-string over a crescent, one tip of which just touches the cavity. The spectator finds himself instinctively compelled to slide the bowl up and down over the tip, but the fiddle-string is not long enough for him to do so more than a little.

More often they have a less aesthetic appearance, such as this one by Dali himself:

Inside a woman's shoe is placed a glass of warm milk in the centre of a soft paste coloured to look like excrement.

A lump of sugar on which there is a drawing of the shoe has to be dipped in the milk, so that the dissolving of the sugar, and consequently of the image of the shoe, may be watched. Several extras (pubic hairs glued to a lump of sugar, an erotic little photograph, etc.) make up the article, which has to be accompanied by a box of spare sugar and a special spoon used for stirring leaden pellets inside the shoe.

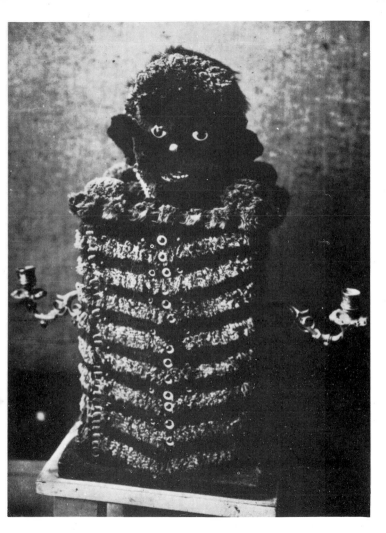

'The Tabernacle', an object found by Yves Tanguy

CHARLES RATTON

14, RUE DE MARIGNAN, PARIS, VIII° ARRONDISSEMENT

POUPÉE KACHINA (ARIZONA) H. 34 CM

EXPOSITION SURRÉALISTE D'OBJETS

MATHÉMATIQUES NATURELS TROUVÉS ET INTERPRÉTÉS
MOBILES IRRATIONNELS OBJETS D'AMÉRIQUE ET D'OCÉANIE

du 22 au 31 Mai

Exhibition catalogues

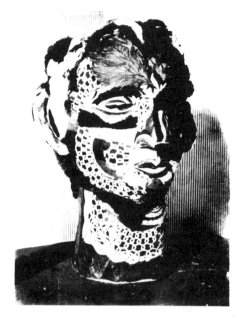

Surrealist
Objects & Poems

LONDON GALLERY, LTD.

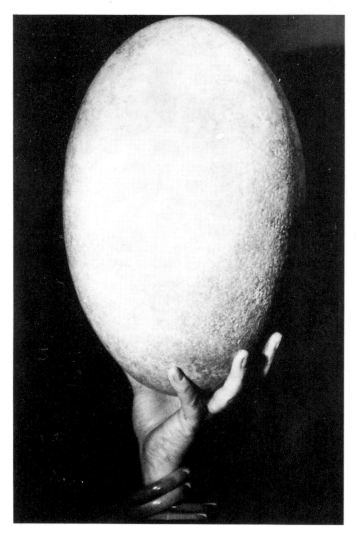

Giant Egg

The Bicycle seat covered with Bees: object found by MERET OPPENHEIM

Found object interpreted by BRIGNONI
LEFT: Graffiti

EXPERIMENTS WITH OBJECTS

In these procedures the object is considered in terms of its possible meanings or functions, as opposed to its actual ones. An 'irrational' approach to knowledge is pursued with the po-faced doggedness of conventional scientific enquiries.

TO DETERMINE THE IRRATIONAL CHARACTERISTICS OF OBJECTS

For any number of players.

A set of questions about a possible object is agreed among the players.

A previously selected object is then revealed or nominated and one of the players reads out the questions one by one, in fairly rapid succession. The others write their answers, which should be brief, concise and immediate. At the end of the experiment they are compared.

This is a record of parts of a game played where the object was A PIECE OF PINK VELVET.

IS IT DIURNAL OR NOCTURNAL?
 Nocturnal. [Y O]
IS IT FAVOURABLE TO LOVE?
 Very favourable, despite its deplorable colour. [R Ca]
IS IT CAPABLE OF METAMORPHOSES?
 Capable: heron, jade, soured wine, mountains. [P E]
WHAT IS ITS POSITION IN RELATION TO THE INDIVIDUAL?
 Completely enveloping the head. [C M]
WHAT ERA IS IT FROM?
 Louis XVI, before the Revolution. [M H]
WHAT ELEMENT IS IT?
 Air. [T T]
WITH WHAT HISTORICAL FIGURE CAN IT BE ASSOCIATED?
 Gérard de Nerval. [A G]

HOW DOES IT DIE?

At night, by hurling itelf into a pond. [A B]

WHAT SHOULD IT MEET WITH ON A DISSECTING TABLE IN ORDER TO BE BEAUTIFUL?

A pair of moustaches. [B P]

WHAT PART OF A SLEEPING WOMAN'S NAKED ANATOMY WOULD YOU PLACE IT ON?

The throat. [A B]

AND IF SHE WERE DEAD?

Lower half of the face, veiling the mouth. [A B]

WHAT ILLNESS DOES IT CALL TO MIND?

Hysteria. [G W]

WHAT PART OF PARIS DOES IT LIVE IN?

French Academy. [T T]

WHAT MIGHT ITS PROFESSION BE?

A martyr. [P E]

IN WHAT MATERIAL DO YOU SEE IT WRAPPED?

Dried sperm, lightly translucent. [T T]

IS IT HAPPY OR UNHAPPY?

Desperate, despite appearances. [B P]

WHAT LANGUAGE DOES IT SPEAK?

English. [M H]

WHO IS ITS FAVOURITE POET?

Verlaine. [J-M M]

WHAT PLACE DOES IT OCCUPY WITHIN THE FAMILY?

A 15-year-old girl who's left the fold. [A G]

HOW WOULD YOU KILL IT?

With a dagger thrust. [R C]

HOW DOES IT GET AROUND?

In an American car driven by a chauffeur. [B P]

WHAT SEXUAL PERVERSION DOES IT CORRESPOND TO?

Female homosexuality. [C M]

WHAT SCENT GOES WITH IT?

Armpits. [R C]

WHICH PAINTER DOES IT CORRESPOND TO?

Manet. [R C]

CERTAIN POSSIBILITIES
RELATING TO THE IRRATIONAL
EMBELLISHMENT OF A CITY

For any number of players.

The players are asked whether they would conserve, displace, modify, transform, or suppress certain aspects of a city.

(As a procedure, these questions could be applied to other objects, systems or concepts.)

This is a partial transcript of a game played on 12 March 1933, the subject: PARIS.

THE ARC DE TRIOMPHE?

Lie it on its side and make it into the finest pissoire in Paris. [P E]

THE OBELISK?

Insert it delicately into the steeple of Sainte-Chapelle. [P E]

THE EIFFEL TOWER?

Conserve it as it is but change its name to 'The Glass of Milk'. [T T]

THE TOUR SAINT-JACQUES?

Demolish it and have it rebuilt in rubber. An empty scallop-shell to be placed on the roof. [T T]

THE VENDÔME COLUMN?

Demolish it, carefully repeating the ceremony of 1871. [T T]

THE CHURCH OF SACRÉ-COEUR?

Make a tram depot of it, after painting it black and transporting it to Beauce. [A B]

LE CHABANAIS (a famous brothel)?

Replace the women with generals. Brothel for dogs. [M H]

NOTRE-DAME?

Replace it with an immense oil cruet in the shape of a cross, one container filled with blood, the other with sperm. A school for the sexual education of virgins. [A B]

THE STATUE OF ALFRED DE MUSSET?

The muse will put her hand in his mouth, people will be invited to punch him in the belly and his eyes will light up. [A B]

THE STATUE OF CLEMENCEAU?

Place on the lawn surrounding it thousands of bronze sheep, one of which is made of camembert. [T T]

THE PANTHEON?

Slice it through vertically and position the two halves 50 centimetres apart. [T T]

THE STATUE OF LOUIS XIV?

Replace it with a bunch of asparagus adorned with the Legion of Honour. [B P]

EXPERIMENT RELATING TO OBJECTIVE PERCEPTION

Each participant has a watch with an alarm which is set to an identical time of which the players are ignorant. They carry on their usual activities, but at the instant the alarm goes off, each player notes down his location and what 'most strikingly impinges on his senses'. Players meet at an agreed time to compare notes.

According to Dali, subsequent analysis would reveal 'to what extent objective perception depends upon imaginative representation (the causal factor, the element of coincidence, symbolical interpretation in the light of dreams etc.). One might find, for instance, that at five o'clock elongated shapes and perfumes were frequent, at eight o'clock hard shapes . . . '

AUTOMATIC SCULPTURE

Sculptures made without conscious intention, for instance while attending a meeting, listening to speeches, riding a bus etc.. Each participant is supplied with a fixed quantity of any sort of malleable material (paper, plasticine, paper-clips etc.). The sculptures produced, together with any remarks by the maker relating to them, are collected and analysed. The questions to determine the irrational characteristics of objects *could be used for this purpose.*

Rolled-up bus ticket from the waistcoat of a present-day bureaucrat (bank employee)

ORAL DESCRIPTION OF OBJECTS PERCEIVED BY TOUCH

The player is blindfolded, touches an ordinary or specially manufactured object, then describes it. The record of each description is compared with the object in question.

Subsequently, the description may be passed on to a third party ignorant of the identity of the original object. He constructs the object from the description alone. The two objects are then compared.

EXAMINATION OF CERTAIN ACTIONS

These experiments are characterized by the authentic Salvador Dali delirium:

Examination of Certain Actions liable owing to their irrationality to produce deep currents of demoralization and cause serious conflicts in interpretation and practice, e.g.:

(a) Causing in some way any little old woman to come along and then pulling out one of her teeth,

(b) Having a colossal loaf (fifteen yards long) baked and left early one morning in a public square, the public's reaction and everything of the kind until the exhaustion of the conflict to be noted.

SURREALIST RE-INVENTIONS

THE 'MARSEILLES' PACK OF CARDS

The Surrealist card-pack resembles the conventional one in format; it has four suits, each with cards numbered from ace to ten, and with four picture cards.

The four suits, and their emblems are as follows:

LOVE: a flame. DREAM: (black) star. REVOLUTION: wheel (and blood). KNOWLEDGE: a lock.

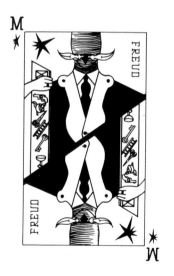

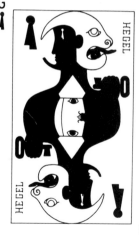

The court cards are replaced by a Genius (instead of a King), a Siren (Queen), a Magus (Jack), and represent the following historical or fictional figures:

	Genius	Siren	Magus
Flame	Baudelaire	The Portuguese Nun	Novalis
Star	Lautréamont	Alice	Freud
Wheel	Sade	Lamiel	Pancho Villa
Lock	Hegel	Hélène Smith	Paracelsus

The Joker is Alfred Jarry's woodcut of Ubu.

THE NEW GAME OF LOTTO

Guy and Rikki Ducornet have replaced the traditional numbers or animals of Lotto boards and cards with a series of collages. These represent male and female characters, emotional states, and places, all of which have strong ties with dreaming.

Anxiety

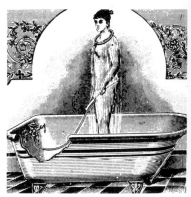

Modesty

PAUL NOUGÉ, A new way of juggling, 1929-30

PROVERBS FOR TODAY

He who bestirs himself is lost.

Cherries fall where texts fail.

Faithful as a filleted cat.

One albino doesn't make a summer.

One good mistress deserves another.

A crab, by any other name, would not forget the sea.

Spare the cradle and spoil the child.

I came, I sat, I departed.

The further the urn the longer the beard.

Beat your mother while she's young.

When reason is away, smiles will play.

Cold meat lights no fire.

A shadow is a shadow all the same.

Why waste rope hanging yourself.

Grasp the eye by the monocle.

Who hears but me hears all.

A corset in July is worth a horde of rats.

Make two o'clock with one clock.

Better to die of love than to love without regret.

Breaking two stones with one mosquito.

Mazes aren't made for dogs.

Never wait for yourself.

Correct your parents.

PAUL ELUARD AND BENJAMIN PÉRET

NEW SUPERSTITIONS

Cupboards left open bring good luck.

Giving dogs extracted teeth to chew brings good luck.

Seeing an army officer is bad luck.
Hold your nose till he has passed by.

Keep the bone of the first sardine eaten in the year,
to ensure no money worries.

Look away when you pass a laundry,
or you'll have bad luck.

Pluck a hair from a neighing horse: good luck.

When you see a flag, turn away and spit
to avert the evil eye.

For good luck break your toothpicks after use.

When passing a police station, sneeze loudly
to avoid misfortune.

BENJAMIN PÉRET

New myths may be invented to 'explain' the universe. Here is the beginning of Breton's THE GREAT TRANSPARENT ONES:

Man perhaps is not the centre, the *cynosure* of the universe. One might easily believe that there exists above him in the scale of animals, beings whose behaviour is as strange to him as his may be to the mayfly or the whale. Nothing seems to prevent these creatures from completely escaping the reference system of the human senses by means of camouflage of whatever nature one cares to imagine: the *theory of forms* and the existence of mimetic animals is alone enough to suggest such a possibility. Doubtless there is plenty of room for speculation here, despite the fact that this notion puts man in the same modest situation vis-a-vis the interpretation of his own universe as a child whose happily mistaken impression of an ant is formed after he has just kicked over an ant-hill . . .

ANDRÉ BRETON

THE NEXT GAME

The revolution we carry inside us will not look like us: so different is it, that we hesitate to bring it into the world. But the game's worth all the candles, since now they're burning at both ends, and that's fine: **the chips are down.**

ALAIN JOUFFROY

MAX ERNST

SURREALIST BIBLIOGRAPHY

ARTAUD: FINANCES ET BON SENS [Money and Common Sense], *Paris, Payot et Cie., 1922.*

BRETON: BRETON'S MELANCHOLIKE HUMOURS, *Kent, Johnson & Warwick, 1815.*
THE ORDER OF AMOROUS DEVICES, 1597, BY BRETON . . . , *Cambridge (Mass.), Harvard University Press, 1936.*
PHILOSOPHIE DU MAGNETISME PAR BRETON, 1854 . . .

CREVEL: LE CRI DES PEUPLES ADDRESSÉ AU ROI, AUX MINISTRES, AUX MARÉCHAUX, AUX PAIRS, AUX DÉPUTÉS, AUX MAGISTRATS, À TOUS LES FRANÇAIS [The people's protestations to the king, the ministers, the generals, their peers, to the deputies, the magistrates, to all Frenchmen], *Paris, L'Huillier, 1817.*

DOMINGUEZ: EL SEDUCTOR, *Madrid, R. Velasco, 1905.*

DUCHAMP: DICTIONNAIRE UNIVERSEL POUR LA TRADUCTION DES MENUS, [Universal Dictionary for translating menus], *Zurich, O. Fussli, 1911.*

ERNST: GESPENSTER IN ALLEN FARBEN UND RACEN [Ghosts in all colours and of all races], *Mayence, 1821.*
SILHOUETTES CREPUSCULAIRES, PAGES VECUES [Twilight silhouettes, pages lived], *Brussels, M. Lamertin, 1921.*

MASSON: LES INCENDIARES [The arsonists], *Brusells, Melin, Cans et Cie., 1847.*
LA SORCELLERIES ET LA SCIENCE DE POISONS . . . [Witchcraft and the science of poisons], *Paris, Hachette, 1903.*

MIRO: EL OBISPO LEPROSO [The leprous bishop], *Madrid, Biblioteca nueva, 1926.*

PÉRET: LA POPULATION, LE BUDGET, LA FORTUNE, ET LA DETTE PUBLIQUE DE LA FRANCE [The French population, budget, resources and national debt], *Paris, Alacan, 1917.*

PICASSO: EL EXPIENDE PICASSO . . . [The expedient Picasso], *Madrid, J. Morata, 1931.*
I GRATTACIELI ED I LORO ALLEATI IN TERRA, IN MARE ED IN CIELO [The Skyscrapers and their allies on earth, in the sea and in the sky], *Genoa, Caimo & Co., 1932.*

SELIGMANN: DE DUBIIS HOMINIBUS IN QUIBUS FORMA HUMANA ET BRUTINA MISTA FERTUR [Of doubtful men in whose bodies human and monstrous forms are said to be mingled], *Leipzig, 1679, s.n.*
DER BÖSE BLICK UND VERWANDTES . . . [The evil eye and the like], *Berlin, H. Barsdorft, 1910.*
PAGAN TRIBES OF THE NILOTIC SUDAN, *London, G. Routledge & Sons, 1932.*

TANGUY: SUR LE SABLE [On the beach]. *Paris, P. Ollendorff, 1899.*

<div align="right">KURT SELIGMANN</div>

DOCUMENTS

KEY TO INITIALS
SOURCES, NOTES, EXPLANATORY TEXTS
OMITTED GAMES
FURTHER READING IN ENGLISH

Surrealism is . . .

Surrealism appears to me in its essentials as a sort of rage, a rage against the existing state of things.

GEORGES BATAILLE

Everything leads me to believe that there exists a certain point, a state of mind in which life and death, the real and the imaginary, the past and the future, the communicable and the incommunicable, high and low, cease to be perceived as contradictions. It would be useless to seek in Surrealist activity any impulse other than the hope of determining this point.

ANDRÉ BRETON (*Abridged Dictionary of Surrealism*)

Surrealism is founded on the belief in the superior reality of certain forms of association, hitherto neglected, in the supreme importance of dreams, the undirected play of thought. It leads to the ultimate destruction of all other mechanisms of thought and to its substitution for them in the resolution of the main problems of life.

ANDRÉ BRETON (*Manifesto*)

The vice known as Surrealism consists of the disordered and passional application of the stupefying *image*.

LOUIS ARAGON (*Abridged Dictionary of Surrealism*)

It is not to belittle Surrealist activity — as it has unfolded from 1924 to the present day — to consider it as a game, in fact as *The Great Game,* whose prizes in the eyes of those who played and lived it, can be calculated in promises of freedom, love, revolution, and in anything else that intransigent desire can aspire to.

PHILIPPE AUDOUIN

Surrealism is the desperate attempt of poetry to incarnate itself in history.

OCTAVIO PAZ

It is true that to some extent Surrealism can be all things to its practitioners, but this constant flux has a consistent central core: a redefinition of freedom in the widest possible terms. With this objective, Surrealism set itelf in stubborn opposition to all the mechanisms of oppression it perceived at work in the world. Not only the obvious institutions of state, religion, the family, etc. but also habits of thought, rationality, causality, the dominance of the conscious mind.

These mechanisms are seen by Surrealism as operating through a system of false dualities, based on Cartesian logic, which must be reconciled or abolished. The Surrealist idea of the 'image' being one means for this end (see note to ONE INTO ANOTHER).

Breton, in his only essay devoted to games (published in MÉDIUM, II, 2, 1954), specifically relates them to these preoccupations:

If there is one activity in Surrealism which has most invited the derision of imbeciles, it is our persistent playing of games, which can be found throughout most of our publications over the last thirty-five years. Although as a defensive measure we sometimes described such activity as 'experimental' we were looking to it primarily for entertainment, and those rewarding discoveries it yielded in relation to knowledge came only later. Certainly we pursued this activity with other considerations in mind; right from the start it proved useful for strengthening the bonds that united us, and for encouraging sudden awarenesses of our desires whenever these were held in common. Furthermore, the urgent need we felt to do away with the old antinomies that dominate work and leisure, 'wisdom' and 'folly', etc — such as action and dream, past and future, sanity and madness, high and low, and so on — disposed us not to spare that of the serious and the non-serious (games).

As for the various games perenially requested, let us note for the record those of scholarly notation (minus 20 to plus 20); definitions (what is . . .); conditonals (if . . . when . . .); 'the exquisite corpse' (written or drawn); intervention of the irrational (characteristics of an object, embellishing a city, elaborating upon a film); the visitor

(would you open the door?), etc, and to the greater satisfaction of the pleasure-principle, those procedures and recipes in the visual arts immediately put within everyone's reach by their inventors: collage, frottage, fumage, coulage, spontaneous decalcomania, candle-drawings, etc.

Luckily the recent publication of Johan Huizinga's work HOMO LUDENS *should make all the leech-like aren't-you-ashamed-of-yourselves-at-your-age crew retire into their worm-eaten shell. This work demonstrates, in fact, that the existence of the game, a free activity if ever there was one, 'affirms in a permanent way and in the highest sense the supralogical character of our situation in the cosmos'. It concludes with the necessity of 'seeing in poetry mankind's realisation of a ludic requirement within the community'. And the great Dutch historian and thinker specifies that 'All things that have come to be recognized in poetry as conscious qualities — beauty, a sense of the sacred, magical power — are implied from the outset in the primary quality of the game.' It is clear that to shut oneself off from game-playing, or at least from the play of the imagination as adult discipline prescribes it, is to undermine the best of one's own humanity.*

Surrealist ideas changed over the many years in which it was active, yet its general direction remained undeviating. After the war Michel Leiris published AURORA*, a novel from his youth of twenty years before. His preface to this work ends with a description which is eminently applicable to the achievements and unchanging ethic of Surrealism itself:

. . . despite the black and frenetic style of its prose, what I like about this work is the appetite it expresses for an unattainable purity, the faith it places in the untamed imagination, the horror it manifests with regard to any kind of fixity — in fact, the way almost every page of it refuses to accept that human condition against which some will never cease to rebel, no matter how reasonably society may one day be ordered.

KEY TO INITIALS

J-L B	Jean-Louis Bédouin		G L	Gerard Legrand
			C M	César Moro
A B	André Breton		J-M M	J-M Monnerot
E B	Elisa Breton		Y O	Yolande Oliviero
R B	Robert Benayoun		B P	Benjamin Péret
R C	René Char		C P	Clement Pansaers
R Ca	Roger Caillois		J P	José Pierre
A D	Adrien Dax		W P	Wolfgang Paalen
G R-D	Georges Ribemont-Dessaignes		B R	Bernard Roger
P E	Paul Eluard		A S	Anna Seghers
T F	Theodor Fraenkel		J S	Jean Schuster
A G	Alberto Giacometti		P S	Philippe Soupault
G G	Georges Goldfayn		J R	Jacques Rigaut
J G	Julien Gracq		T	Toyen
M H	Maurice Henry		T T	Tristan Tzara
S H	Simon Hantaï		G W	Georges Wenstein
			M Z	Michel Zimbacca

ABBREVIATIONS

* Entry in FURTHER READING LIST IN ENGLISH, p. 164

SASDLR The periodical SURRÉALISM AU SERVICE DE LA RÉVOLUTION

BLS BULLETIN DE LIAISON SURRÉALISTE

'Audouin' refers to the only study of Surrealist games, by Philippe Audouin in
DICTIONNAIRE DES JEUX, ed. René Alleau, Tchou, Paris, 1964.

PAGE 2: COMPENSATION PORTRAITS Invented by Breton and Duchamp for the exhibition catalogue FIRST PAPERS OF SURREALISM, 1942. The exhibition was held in New York during the war, making it difficult to obtain photographs of some of the participants.

PAGE 17: AUTOMATIC (writing) In the MANIFESTO OF SURREALISM* (1924), Breton defined Surrealism and Automatism in terms of each other:

SURREALISM, n. Psychic automatism in its pure state, by which one proposes to express — verbally, by means of the written word, or in any other manner — the actual functioning of thought. Dictated by thought, in the absence of any control exercised by reason, exempt from any aesthetic or moral concern.

In the same work he described how he and Soupault came to write the first texts using this method:

Completely occupied as I still was with Freud at that time, and familiar as I was with his methods of examination which I had had some slight occasion to use on some patients during the war, I resolved to obtain from myself what we were trying to obtain from them, namely, a monologue spoken as rapidly as possible without any intervention on the part of the critical faculties, a monologue consequently unencumbered by the slightest inhibition and which was, as closely as possible, akin to spoken thought. It had seemed to me, and still does, that the speed of thought is no greater than the speed of speech, and that thought does not necessarily defy language, nor even the fast-moving pen. It was in this frame of mind that Philippe Soupault — to whom I had confided these initial conclusions — and I decided to blacken some paper, with a praiseworthy disdain for what might result from a literary point of view. The ease of execution did the rest. By the end of the first day we were able to read to ourselves some fifty or so pages obtained in this manner, and begin to compare our results. All in all, Soupault's pages and mine proved to be remarkably similar: the same overconstruction, shortcomings of a similar nature, but also, on both our parts, the illusion of an extraordinary verve, a great deal of emotion, a considerable choice of images of a quality such that we would not have been capable of preparing a single one in longhand, a very special picturesque quality and, here and there, a strong comical effect.

Automatic writing derived from experiments carried out by the Surrealists during the so-called 'Period of Sleeping-Fits' when certain of them put themselves into trance states and were able to write and draw with surprising facility. Robert Desnos was particularly adept; he could compose rhyming sonnets in

trance states, but the ease with which he was able to fall into trances was eventually one reason why these experiments were ended: there was a serious risk to his sanity. Automatism, being free of conscious control, offered a way out of the impasse of Dadaism, a return to writing but not to literature, an authentic expression free of aesthetic criteria and from the associations of a language half-dead from habitual usage.

The method of automatic writing was suggested by two distinct sources. Breton, a former medical student, was aware of Pierre Janet's book L'AUTOMATISME PSYCHOLOGIQUE which describes automatic writing in a diagnostic context. The other source was the practices of mediums, shorn of any 'other-worldly' associations. The first medium to be examined scientifically was Hélène Smith in Theodor Flournoy's FROM INDIA TO THE PLANET MARS*; the Surrealists dubbed her 'The Muse of Automatic Writing' and her photograph appeared in several of their publications. Hélène Smith received communications from Mars in the Martian alphabet (which she was fortunately able to translate into French).

Later, Breton became aware of an even more remarkable precursor, that of Horace Walpole. Walpole wrote the first gothic novel, THE CASTLE OF OTRANTO (1764), using a purely Surrealist technique. The initial image of the book derived from a dream, which Walpole elaborated upon in a frenzy of writing that in only a few days resulted in the completed novel. In 1722 he wrote his HIEROGLYPHIC TALES, which he explained, were 'written extempore and without any plan', in other words: automatically.

There are two well-known descriptions of automatic writing — by André Breton: WRITTEN SURREALIST COMPOSITION, OR FIRST AND LAST DRAFT (MANIFESTO OF SURREALISM,* 1924), and Benjamin Péret: AUTOMATIC WRITING (1929, but not published until 1987, in his OEUVRES COMPLÈTES, Vol. IV). Both stress the emptying of the mind: *Forget about your genius, your talents, and the talents of everyone else. Keep reminding yourself that literature is one of the saddest roads to everything.* (Breton) *Forget all your preoccupations, forget that you are married, that your child has whooping-cough, forget that you are a senator, or a disciple of August Comte or Schopenhauer, forget antiquity, forget about any literature from any place in the world and in any period of history. You no longer want to know what is logical and what is not* (Péret). Breton, and other Surrealists who found themselves less able to write by this method, preferred to write jointly with someone else. This speeds the process up — one person reads a sentence or phrase while writing it down, the second follows on, reading the addition. This reduces the lag-time between speaking and writing, and speed is necessary to exclude conscious elaboration

of the text as it appears. Since Automatic Writing is simply a tool, the results vary according to whoever is writing, and to some extent according to their intentions, conscious or otherwise. Breton and Soupault's text (from THE MAGNETIC FIELDS*, 1920) betrays the influence of Rimbaud and Lautréamont. The other three exponents were gifted at writing automatically on their own. Desnos' text is from GRIEF UPON GRIEF*, 1924; Péret's from DEATH TO THE PIGS AND THE FIELD OF BATTLE*, written in 1922. In this novel each chapter parodied a literary genre; the letter here is from his Surrealist version of the epistolary novel. Césaire's poem is from SOLAR THROAT SLASHED*, 1948. Césaire is a poet from Martinique where he has been the island's leftist deputy in the French National Assembly for more than thirty years.

PAGE 22: SIMULATION In 1930, in just a couple of weeks, and writing only in their spare moments, André Breton and Paul Eluard composed THE IMMACULATE CONCEPTION*. Intended to express the interior and exterior life of man from CONCEPTION and INTRA-UTERINE LIFE to DEATH and THE ORIGINAL JUDGEMENT, it was written using more 'active' forms of automatism. All the sections, and their titles, were settled beforehand — the text was directed by these signposts. Some sections included 'found' elements, captions from scientific journals inserted in mid-sentence; another section was a re-writing of a review of a concert at an Alpine resort. The authors transposed the musicians into celebrated murderers, the mountain location into beneath the sea, and continued from there

The most famous form of directed automatism is the SIMULATION. (As a medical intern during the war, Breton had encountered patients simulating mental illnesses, for obvious reasons.) In their preamble, the authors stress that *the slightest suggestion of any borrowing from clinical texts or of pastiche, skilful or otherwise, of such texts, would be enough to make these pieces both pointless and wholly ineffective.* Their aim was to *prove that the mind of a normal person when* poetically *primed is capable of reproducing the main features of the most paradoxical and eccentric verbal expressions and that it is possible for such a mind to assume at will the characteristic ideas of delirium*

The other SIMULATIONS attempted in this book are of ACUTE MANIA, GENERAL PARALYSIS, INTERPRETATIVE DELIRIUM and DEMENTIA PRAECOX. The experiment does not seem to have been repeated.

The SIMULATIONS had another function. In NADJA Breton had encouraged those incarcerated in mental hospitals to murder the doctors so as to escape their attentions. The SIMULATIONS were partially intended to keep this dispute on the boil. Enemies tend to forget offences committed against them and a care-

fully aimed insult or provocation is occasionally necessary to keep them in a satisfactory state of bilious indignation. Otherwise the SIMULATIONS aimed to *'resolve the antinomy between reason and madness'* and to demonstrate the fictional nature of this duality.

PAGE 24: CHAIN GAMES The principal reason for the influence of Surrealism is its emphasis on *collective* activities, which were remarkably disciplined and well-organized. The emphasis on the collective was also an opposition to the idea of the artist as an individual talent and an attempt to wrest expression from 'the professionals'. Within this context the game is the perfect way of involving 'amateurs' in collective creative acts.

 Breton, in the SECOND MANIFESTO* (1930), felt that in these games a mysterious collective imagination was made manifest, in ways the participants could not quite grasp.

In the course of various experiments conceived as 'parlour games' whose value as entertainment, or even as recreation, does not to my mind in any way affect their importance: Surrealist texts obtained simultaneously by several people writing from such to such a time in the same room, collaborative efforts intended to result in the creation of a unique sentence or drawing, only one of whose elements (subject, verb, or predicate adjective — head, belly, or legs) was supplied by each person, in the definition of something not given, in the forecasting of events which would bring about some completely unsuspected situation etc., we think we have brought out into the open a strange possibility of thought, which is that of its pooling. The fact remains that very striking relationships are established in this manner, that remarkable analogies appear, that an inexplicable factor of irrefutability most often intervenes, and that, in a nutshell this is one of the most extraordinary meeting grounds.

PAGE 25: THE EXQUISITE CORPSE The Surrealists first played this game, derived from the French parlour game *petits papiers,* similar to the English game of 'Consequences', around 1925. Breton's first wife, Simone Collinet, described (in LE CADAVRE EXQUIS, SON EXALTATION*, Galleria Schwarz, Milan, 1968) how they chanced upon it:

It was during one of those idle and tedious evenings, frequent at that time — contrary to subsequent descriptions which benefit from hindsight — that the Exquisite Corpse was invented.

 Someone said: 'How about playing Consequences? That's entertaining.' So we played the traditional game of Consequences. Monsieur meets Madame, he

says to her, and so on. But not for long. The game rapidly became something else. 'Just write down anything at all', Prévert suggested.

In the next round, the Exquisite Corpse was born. From Prévert's pen, as a matter of fact, for he wrote the first words, so perfectly complemented by those following; one wrote: 'shall drink the new'; the next: 'wine'.

Once their imagination was let loose, it couldn't be stopped. André exclaimed with delight and immediately saw in it one of those wellsprings or natural outpourings of inspiration he so loved to discover. A torrent was unleashed.

Even more reliably than with automatic writing, one was sure of jarring amalgams. Violent surprises prompted admiration, laughter, and stirred an unquenchable craving for new images — images inconceivable to one brain alone — born from the involuntary, unconscious and unpredictable mixing of three or four heterogeneous minds. Some sentences took on an aggressively subversive existence. Others veered into an excessive absurdity. The wastepaper basket played its part. One tends to forget that.

The fact remains that the suggestive power of these arbitrary juxtapositions of words was so startling and dazzling and validated Surrealist theories and inclinations in such a striking way that the game became a system, a method of research, a means of exaltation and stimulus, a mine, a treasure-trove and finally, perhaps, a drug.

Both Tristan Tzara (op. cit.) and Georges Hugnet (in PETITE ANTHOLOGIE POETIQUE DU SURRÉALISME, Bucher, 1934) give the procedure for this game.

The method could be adapted more directly for poetry. While travelling to Avignon, Eluard, Breton and René Char used it to compose a book of poems RALENTIR TRAVAUX (SLOW UNDER CONSTRUCTION*) in 1930.

The Belgrade Surrealists played a longer variant in which each player wrote a sentence and concealed all but the last phrase or word. The next player did the same and so on.

The examples are from LA RÉVOLUTION SURRÉALISTE, no. 9/10, 1927 and SASDLR, no. 4, 1931.

PAGE 26: THE GAME OF DEFINITIONS Originally published under the title of THE DIALOGUE in 1928 (or 1934, depending on the year in question). This game first appeared in LA RÉVOLUTION SURRÉALISTE, no. 11, 1928, prefaced by the following observation:

A question? An answer. A simple process of give and take which implies all the optimism of conversation. The two interlocutors pursue their separate

thoughts. The occasional affinity, even if contradictory, is imposed by coincidence. A comforting procedure, in short, since there is nothing better than to ask questions, and to reply to them.

PAGE 28: THE GAME OF CONDITIONALS From VARIÉTÉS, Brussels, June 1929, special issue: LE SURRÉALISME EN 1929.

PAGE 29: THE GAME OF SYLLOGISMS This game appears to be unpublished. It was among a group of manuscript versions of Surrealist games sold in 1989 by Claude Roffat in Paris. The presence of Breton and Péret among the players dates it to the 1950s. The catalogue of the sale gives the rules and furnishes a single, unattributed, example.

PAGE 29: THE GAME OF OPPOSITES This, the last in the series of paper-folding games, is perhaps the most elegant. It dates from a much later period than the others, for it was invented by Michel Zimbacca and first published in the last magazine of the Paris Surrealists, the BULLETIN DE LIAISON SURRÉALISTE, no. 1, 1970. Later issues, nos. 3 and 4, contain many examples, some with as many as eleven players. Issue 4 also contains a variant on the game. In this version one player writes a sentence, the others individually negate it, the negations are compared.

PAGE 29: ECHO POEMS Aurélien Dauguet described his invention in BLS, no. 5, 1972. He gives three examples, two of which are not translatable as they are based on phonetic procedures.

PAGE 30: THE GAME OF ONE INTO ANOTHER Breton and Péret invented this game in 1954 as a way of systematizing an important area of Surrealist thought, that of metaphor, analogy and the 'image'. In Surrealist estimation, the success of an image, essentially a metaphorical coupling of two terms, is greater the further apart the two terms habitually are; in other words, the more extreme the metaphor. This coupling of two terms of reality not normally associated with one another is an essential part of the Surrealist idea of beauty, and is intended to signify the possibility of relations existing in the world other than those usually perceived. A different sort of causality is asserted, or at least hinted at. The image also has an obvious relationship with Surrealism's consistent aim of abolishing, or reconciling, contradictory forces.

Breton's published account of the game appeared in MÉDIUM (II, 2, 1954), and was prefaced by the remarks on games already quoted. He then relates the game

to analogy and metaphor, and to the occultists' theory of Correspondences, in which *'every object belongs to a unique ensemble and is linked to every other object of this ensemble by necessary relationships . . . '* He describes the game's beginning:

*. . . one evening the discussion returned once again to analogy. Searching for an example to validate what I was defending, I resorted to saying that a **lion** could easily be described through the **match** I was preparing to strike. Indeed, it immediately struck me that the lit flame of the match would in this case 'yield' the mane and going on from there only a few words would be needed to differentiate or particularize the match in order to set the lion upon his feet. The lion is **in** the match, just as the match is **in** the lion.*

This idea, that any object whatever is thus 'contained' within any other object and that one only need distinguish the former through certain features (relating to substance, colour, structure, dimensions) in order to arrive at the latter grew within me, unformulated, until Péret and I came to reconsider this question in greater depth.

Breton concludes his account thus:

*It is of prime importance to emphasize that during the three hundred or so games of ONE INTO ANOTHER which followed with a variety of participants, **we never experienced a single failure.** Sometimes the solution was supplied with stunning speed, inexplicable in terms of what little had previously been said.*

*. . . Various examples follow of some of these **allegorical sketches.** Needless to say they were interrupted at the precise moment when the object being described — quite indirectly, by proxy passed onto the other — was discovered. At least they offer the attraction of not fitting into any 'genre', of not reminding one of anything too familiar — or almost.*

*I put 'almost'. If indeed one wanted at all costs to categorize them, their category would have to be that of **the riddle.** Huizinga, who points out 'the close correlation of poetry to riddle', stresses the importance of the riddling competition among sacrificial cults and the vital role it played within the Vedic tradition in particular.*

PAGE 32: THE GAME OF VARIANTS Breton's account of this game, which he discovered surprisingly late considering it is at the root of many Surrealist games, is given in CAHIERS D'ART, no. 5/6, 1935.

The players in the game cited by Breton included a child of five, a deaf old woman and someone not fluent in French.

PAGE 32: TRANSLATION POEMS This game for jaded academics was illustrated, under the title THE BREATHING EYE OF LANGUAGE in the English magazine TRANSFORMACTION, nos. 7 & 8, 1976-7. The original poem (not given) is Luis de Gongora's DE LA BREVEDAD ENGAÑOSA DE LA VIDA, and the translations by Pierre Dhainaut, Laurens Vancrevel, Ken Smith and Arni Thorgeirsson are from/into Dutch, Czech, Icelandic, French and English. They are variously described as: literal, spontaneous, paranoiac, 'vaguely Rousselian', and idiomatic-syncratic.

Three versions of the final verse illustrate the transformations. The first, un-attributed, is a literal version of the Icelandic (which is already five stages removed from the original); the second, by Laurens Vancrevel, is his literal ver-sion of the Dutch translation, which was four stages from the original. The third version is Ken Smith's idiomatic-syncratic rendering of the same Dutch transla-tion:

You will have to appear before the judge in this city:
He is a bulb giving pitch darkness.
He walks fast in the darkness giving you Death.

In this City one is not safe from stupidity.
Clothes are made of glass and light and black coal
and sharp dazzling rays bring forth death.

Better a bald head than a ringing spittoon;
waving the unlit lamp's a cold fart's work;
you saddle your dragon, I mine.

A not dissimilar process, but one which yields far less interesting results, if those published are anything to go by, is that of CHAINPOEMS, outlined by Charles Henri Ford in the 1940 issue of NEW DIRECTIONS. It can also be played as a postal game. Poets each contribute a line to a poem in turn, all the previous contributions being known to all the participants. There are no other rules except that any participant may decide when the poem is complete, at which point a copy of the poem is mailed to all the previous players.

PAGE 33: THE GAME OF ILLÔT-MOLLO Hervé Delabarre gives a description of this game (BLS, 2, 1971) in an article prefacing a discussion of the next game — Parallel Stories. The two games are very similar, but seem to have been invented independently. That of Illôt-Mollo (the name remains obscure) was invented in 1969 by André Cariou. Both are attempts at breathing new life into automatic writing.

PAGE 34: THE GAME OF PARALLEL STORIES This game, apparently taught to Hervé Delabarre by an unknown traveller, is described by him in the article cited above. It is a more relaxed and, paradoxically, more productive version of Illôt-Mollo.

Micheline Bounoure in her presentation of the game (op. cit., no. 1) suggested the following context for the stories:

Each player independently writes the 'automatic' account of an identical event, one which they all could have witnessed.

As if the phases of this event had been forgotten, each in turn tries to make them reappear by saying out loud one reference-word that everybody immediately incorporates in the accounts they are engaged in writing down privately.

As with all forms of automatic writing, speed of composition is important.

PAGE 36: TO MAKE A DADAIST POEM This recipe, given here in Tzara's own words, is from the MANIFESTO OF MR AA THE ANTI-PHILOSOPHER (1924) and included in SEVEN DADA MANIFESTOS AND LAMPISTERIES.*

Breton later adapted this formula and put it to more Surrealist use by reducing its aleatory properties and using longer phrases.

PAGE 37: FOUND POEM Poem by 'Workers of the American Type Foundry' published in VIEW, II, 4, 1942.

PAGE 38: Breton adapted Tzara's formula by using longer phrases which he fitted together. The example is from SOLUBLE FISH, 1924.

PAGE 39: TO MAKE A SURREALIST STORY Roger Roughton, the editor of the English Surrealist review CONTEMPORARY POETRY AND PROSE, used a similar method to produce this text, published in the December 1936 issue. It is constructed entirely of passages from the LONDON EVENING STANDARD of June 6, 1936. Roughton committed suicide in 1941, aged 25.

PAGE 40: THE METHOD OF RAYMOND ROUSSEL Raymond Rousel was without doubt the strangest and most eccentric personality on the fringes of Surrealism. Immensely rich, he devoted his life and fortune to writing intense, bizarre works almost entirely based on systems of puns. When he left France for the last time, aged 36, he arranged for a book to be published posthumously which would explain his method: HOW I WROTE CERTAIN OF MY BOOKS. Both the method and example here are taken from it.

His method creates an 'equation of facts' which must be solved narratively. Later Roussel took to inserting more and more sets of double meanings into each narrative. He derived them from distortions of found phrases: verses from Hugo, advertisements, his shoemaker's address. All produced events, objects and people to be incorporated into specific sections of his work. From this laborious process he produced two extraordinary novels, IMPRESSIONS OF AFRICA* and LOCUS SOLUS*, in which incredible events are described in a dead-pan style. Later on, his method got out of control; it became too successful, incidents flooded in too fast, were more and more complex. His last, unfinished (and unfinishable) novel* was reduced to a delirious plot synopsis — he only managed to write out one-fifth of it, yet it runs to over 70 pages of dense notations of events. He died, perhaps by suicide, in 1933.

PAGE 43: DIRECTIONS FOR USE Jean-Claude Silbermann presented this procedure — not specifically a game, but a method with obvious ludic qualities and many possible applications — in LA BRÈCHE, no. 6, 1964. He prefaced his examples:

I have a sneaking fascination for DIRECTIONS FOR USE. *I read them most attentively. I have the feeling I understand them. They seek to make me perform a small number of precise gestures, perfectly suited to the product for whose use they are meant to provide . . . directions (as their name indicates), and upon which the meaning of the ritual depends. Such products usually aim at purification: we are invited to 'wash our stubbornest stains and most engrained dirt in best SUPERCLEAN foam . . . ' I throw myself into it like one afflicted with the plague. The limpid rite is faced with my personal obscurity. It sets to greedily but clearly finds enough there to confuse it, to put it off the rails: since it reappears in the form of a product whose purpose is the maintenance of my reverie, having assisted me meanwhile to return to the forest these tracks that are too clearly marked.*

PAGE 48: LEONARDO DA VINCI — TREATISE ON PAINTING Surrealist artists, and Ernst in particular, frequently refer to this formula of Leonardo's, and many Surrealist methods are intended to create artificial equivalents to the 'blots' and 'streams' Leonardo recommends.

PAGE 49 : The most coherent statement of Surrealist theory of the techniques which follow is Max Ernst's essay INSPIRATION TO ORDER, which appeared in SASDLR, 6, and in English in THIS QUARTER, in September 1932. Ernst stresses the fact that these processes free the image from the sway of conscious

faculties, and that the artist's share in the elaboration of a work is reduced to a minimum: it becomes that of a spectator. Ernst concludes his description with this assertion:

I think I am entitled to say without exaggeration that surrealism has enabled painting to travel with seven-league boots a long way from Renoir's three apples, Manet's four sticks of asparagus, Derain's little chocolate women, and the Cubists' tobacco-packet, and to open up for it a field of vision limited only by the irritability capacity of the mind's powers. Needless to say, this has been a great blow to art critics, who are terrified to see the importance of the 'author' being reduced to a minimum and the conception of 'talent' abolished. Against them, however, we maintain that Surrealist painting is within the reach of everybody who is attracted by real revelations and is therefore ready to assist inspiration or make it work to order.

PAGE 48: Surrealist art aims not at a representation of the world, nor at a formal aesthetic such as that espoused by the Cubists or the much-loathed Cézanne (see WOULD YOU OPEN THE DOOR?), but at a representation of unsuspected relations which intimate how the world *could* be. The part played by the unconscious is important, since the reconciliation of the dualities of unconscious/conscious and dream/reality is part of the process, and the hidden must first be revealed.

The techniques in MANIPULATING CHANCE are methods of achieving this 'drawing out'. Inspiration can be forced, subdued, short-circuited; it is a lightning-rod between the poles of great divides, a connecting bridge.

The Exquisite Corpses exactly personify this conception of inspiration, gods or monsters, created from metaphor. Similarly the paranoiac-critical method is a sort of summing-up of all these processes, in which one term is put in place of another, and eventually overwhelms it. Analogy and metaphor are taken to the ultimate; it is not a question of x is like y, but x *becomes* y — and then z . . .

PAGE 49: AUTOMATIC DRAWING has similar sources to writing: from mediums/psychics (such as Mme Smead) and from 'primitives' and psychotics (as represented here by Max's figure, from the 'Outsiders' exhibition catalogue). Surrealist interest in both fields was intense, and Breton related them to automatism in his article LE MESSAGE AUTOMATIQUE (MINOTAURE, 3/4, 1933). The drawing by Mme Smead is from the same article.

The brush drawing by Paalen is perhaps not as 'automatic' as the others; it was drawn for the cover of MÉDIUM II, 2, 1954.

PAGE 53: FUMAGE was the invention of Wolfgang Paalen who used it as the basis for many of his paintings.

PAGE 55: Ernst described his discovery: *One rainy day in an inn at the seaside, I found myself remembering how, as a child, an imitation mahogany panel opposite my bed had served as an optical catalyst for visions on the edge of sleep. I was struck by the obsession exerted upon my excited gaze by the floor — its grain accented by a thousand scrubbings. I thereupon decided to explore the symbolism of this obsession, and to assist my contemplative and hallucinatory faculties I took a series of drawings from the floorboards by dropping sheets of paper on them at random, then rubbing them with a soft pencil.* Ernst compares the results to his childhood hypnagogic visions, and stresses that the material soon loses all resemblance to itself, becoming images of other natural or imagined forms.

PAGE 55: DECALCOMANIA WITH NO PRECONCEIVED OBJECT This process, discovered by Oscar Dominguez, was first published in MINOTAURE, 8, 1936, under the title HOW TO OPEN AT WILL THE WINDOW ONTO THE MOST BEAUTIFUL LANDSCAPES IN THE WORLD AND ELSEWHERE. It was accompanied by a number of examples (including this one by Jean), which were interpreted in the form of a story by Benjamin Péret. Dominguez invented a number of variants of the process by using stencils to produce the image on the first sheet.

The word 'decalcomania' derives from the French *décalquer,* to transfer. Decalcomania proper was a popular parlour pastime of the 1860s in which fashionable ladies exercised their creativity with transfers onto glass.

ÉCRÉMAGE was the invention of the English artist Conroy Maddox.

PAGE 58: TORN PAPER COLLAGE According to Arp, he discovered this process by accident. Dissatisfied with a drawing, he tore it up and let the pieces fall to the floor. Only later did he notice that the arrangement resembled that which he had failed to discover consciously. The process has obvious similarities to Tzara's poem.

PAGE 59: OTHER TECHNIQUES: GRATTAGE has been principally employed by Ernst, Simon Hantaï and Esteban Frances. SAND PAINTING by Masson, and FROISSAGE by Ladislav Novak.

In Germany COULAGE is popularly practised under the name of

BLEIGIESSEN on New Year's Eve. Nowadays one buys a packet which contains a spoon and small pieces of lead shaped into lucky charms. These are melted in the spoon and poured into water; interpretation of the shapes sheds light on events in the year to come.

There are numerous other techniques employed by Surrealist artists: Vane Bor's use of crumpled tissue paper stuck to canvas and worked over; Adrien Dax's use of methods akin to marbling; even Dali's 'Spasmo-Graphism' (draw with one hand while masturbating with the other).

PAGE 60: SURREALIST COLLAGE Ernst's collage technique has become so familiar that it is hard to see afresh. Despite the fact that numberless artists have employed it, none has ever produced such striking results as Ernst in his three collage 'novels'. These narratives represent the perfect Surrealist 'encounter', that moment when the subject and the world briefly coalesce. The fact that he used as his raw materi l totally banal and deliberately characterless engravings makes this representation all the more appropriate.

The collage is from the most famous of Ernst's novels: LA FEMME 100 TÊTES (1929). The Styrsky was reproduced in LA BRÈCHE, 4, 1963.

PAGE 64: INIMAGE is the invention of René Passeron.

PAGE 66: WHAT A LIFE! was published by Methuen in 1911, the work of the journalist E V Lucas and George Morrow, the illustrator. The pictures derive from 'Whiteley's' shopping catalogue (Harrods had refused permission). It seems to have been discovered by Raymond Queneau who wrote an essay about it for DOCUMENTS in 1936.

PAGE 70: THE PARANOIAC-CRITICAL METHOD This method, invented and promoted by Dali in the 1930s, was described by him in numerous texts of barely comprehensible delirium. One of his clearest definitions is that it is an attempt to 'systematise confusion through a violently paranoiac will'. The aim is to make the images superimposed on reality by the subject more real to both himself and everyone else. Reality becomes a continous flux, as depicted in Dali's paintings of the period.

Breton saw this method, with its implicit attack on automatism, as a too-passive activity, a simple generalisation of previous methods such as frottage etc. (ENTRETIENS).

The photograph of the 'face' was first published by the Surrealists in SASDLR, 3, 1931 where Dali compared it stylistically to the portraits then being painted by Picasso.

In 1936, Antonin Artaud was in Mexico. His account CONCERNING A JOURNEY TO THE LAND OF THE TARAHUMARA describes a whole landscape which has been overwhelmed by simulacral images which relate to the mythical beliefs of the native Indians, to a landscape in which paranoiac-critical phenomena are embodied in the rocks and mountains, a landscape of endlessly repeating signs.

PAGE 73: THE GAME OF THE EXQUISITE CORPSE Simone Colinet, in her article quoted earlier, points out that the best results are frequently the work of non-professionals. 'Artists' styles are too intrusive to create a real amalgamation.

Most of the exquisite corpses drawn by the Surrealists accept the convention that the object depicted is in some way a figure, however monstrous, although a few of them, usually those in which the folds are vertical to the picture, result in 'landscapes'. One can imagine many other ways of arranging the folds on a sheet, which could give quite different results (for instance, by folding the sheet into diamond shapes).

The game can be played by any number of people: Ted Joans, the American Surrealist poet, has been assembling a 'corpse' since 1975; now around fifty feet long, it includes panels by Ginsberg, Leiris, Gascoyne, Rosenquist, Burroughs, Mansour, Jaguer, Soyinka and Octavio Paz, among many others.

It is interesting to note that Otto Dix and Christoph Voll were producing similar drawings in 1921, three years before the first exquisite corpse.

PAGE 78/79: POTATO CUTS AND PAPER CUTS Other Surrealist uses of traditional pastimes. The potato cuts (by Heisler and Péret) illustrated a selection of Félix Feneon's mordant newspaper space-fillers, celebrated in their day and long after.

The paper-cuts by Breton seem to have been influenced by ones he saw in Mexico.

PAGE 83: SURREALIST INQUIRIES are intended to elucidate the world from the Surrealist viewpoint and to define the exact position of Surrealism on the various topics considered. The length and number of responses to these inquiries is impossible to present here — this section is limited to the more interesting examples and to summarising the responses.

Inquiries and questionnaires seem to have a passionate attraction for French intellectual groups and many appear in Surrealist periodicals. Three or four in particular stand out as having been important in forming Surrealist attitudes:

'Why do you write?' (LITTÉRATURE, 1919). Responses range from the flippant to the inane.

'Suicide: is it a solution?' (LA RÉVOLUTION SURRÉALISTE, 1925). Responses which considered this question as a moral one come in for editorial abuse.

'What sort of hope do you place in love?' (LA RÉVOLUTION SURRÉALISTE, 1929).

'What was the most important encounter in your life?' (SASDLR, 1933).

The inquiry conducted by LE GRAND JEU, a para-Surrealist grouping, is also worth mentioning: 'Would you sign the celebrated pact with the devil?'

The questions presented here as 'Thought for the Day' appeared in various issues of BIEF, and JONCTION SURRÉALISTE in the late 1950s under the title of 'This Month's Questions'.

PAGE 84: WOULD YOU OPEN THE DOOR? This game is from MÉDIUM, II, no. 1, 1953. The complete results, in order of approval, are: Baudelaire, yes 100%; Gustave Moreau, yes 100%; Novalis, yes 100%; De Quincey, yes 100%; Charles Fourier, yes 94%; Freud, yes 94%; Nerval, yes 94%; Nouveau, yes 94%; Gauguin, yes 88%; Lenin, yes 88%; Henri Rousseau, yes 88%; J-J Rousseau, yes 88%; Goya, yes 87%; Juliette Drouet, yes 87%; Brisset, yes 86%; Fulcanelli, yes 86%; Hegel, yes 82%; Huysmans, yes 82%; Van Gogh, yes 76%; Seurat, yes 71%; Stendhal, yes 67%; Marx, yes 65%; Barbey d'Aurevilly, yes 62%; Nietzsche, yes 60%; Hugo, yes 59%; Mallarmé, yes 59%; Balzac, yes 56%; Goethe, yes 50%, no 50%; Bettina, no 54%; Poe, no 56%; Chateaubriand, no 59%; Verlaine, no 87%; Cézanne, no 88%.

PAGE 86: THE GAME OF SCHOLARLY NOTATION This game dates from the very early 1920s, and so the attitudes indicated are from the Paris Dada era. The only published version of this game was in LITTÉRATURE (March 1921), in which historical and contemporary people were evaluated. The version here, from the same period, was not published until 1965, in Michel Sanouillet's DADA À PARIS. It is from the archive of Tristan Tzara, and the selection is approximately 10% of the whole. (Blanks indicate a player's absence from that particular session.)

Breton, in his ENTRETIENS (1952), recalled these games, which were played at an early meeting-place, the Café CERTA in the Passage de L'Opéra. He calls attention to the difference in response between those about to break with Dada, and the Dadaists who did not make the move to Surrealism (Ribemont-Dessaignes, Tzara, Pansaers, Soupault). These games gave the group an internal cohesion it would otherwise have lacked, although the section on page 86

already approaches the inquisitorial.

Scholarly Notation also resembles the famous LISEZ/NE LISEZ PAS (Read/Don't Read) list which appeared on the back page of catalogues for ÉDITIONS SURRÉALISTES in 1931:

PAGE 88: THE GAME OF ANALOGY CARDS Jean-Louis Bédouin presented this game of psychological analogy in the last issue of LE SURRÉALISME, MÊME, 1959. He explains that it had its origin in an attempt to assign various more or less well-known historical figures to the categories of human personality laid out by Charles Fourier, the Utopian socialist. Bédouin recommends that the person portrayed be someone well enough known to the group for them to arrive at meaningful results. Given this restriction, remarkable accords may occur. Bédouin mentions, for instance, that when the time came to read answers for the Freud analogy card, three different people had suggested his place of birth as 'Giza, at the foot of the Sphinx'. Analysis of the various answers to the questions demonstrates the twofold nature of the game — it at once illuminates the personality of the individual depicted and those of the collective who are playing it.

. . . for the same reason as other Surrealist games, the analogy card game is more than just a means of amusement: it's a form of privileged activity linked to a poetic conception of life, a way of being serious without the worry of seeming so, a manner of dispelling solitude thanks to the unlimited exchange of worthwhile perceptions.

The cards, as presented in LE SURRÉALISME, MÊME were accompanied by pictures of the categories 'Domicile' and 'Photograph', which make them more like Identity Cards than the one given here.

PAGE 90: THE TRUTH GAME There are no published versions of this game. The reason is contained in Philippe Audouin's description, here quoted in full.

This game, which consists of 'telling the truth' whatever the question posed, is not strictly speaking Surrealist. In point of fact the Surrealists played it incessantly and if it scarcely featured in subsequent publications, this is because it caused disagreements that were already too severe for anyone to consider worsening them by making them public.

Without of course any smutty complaisance entering into it, it was actually to do with a quasi-ritualistic stripping of those present, an ordeal to the symbolic death, and apparently, Lévi-Strauss — several times called upon to par-

ticipate in this awesome game — regarded it (according to André Breton) as equivalent to an initiation rite.

René Crevel, in his article of 1934 (NOTE EN MARGE DU JEU DE LA VÉRITÉ, DOCUMENTS 34, 20), described what the game meant to the Surrealists: the casting aside of an individual's shames, fears and subjective errors, a prelude to freedom.

Since there are no published versions of this game, the text given here is a close approximation: selections from the RECHERCHES SUR LA SEXUALITÉ, most of which appeared for the first time in 1990 (ARCHIVES DU SURRÉALISME, 4, Gallimard/ACTUAL). This investigation comprises twelve sessions, which occurred between January 1928 and August 1932 (the first two sessions were published in LA RÉVOLUTION SURRÉALISTE, 11, 1928). It is impossible to give a full flavour of these extraordinary conversations: there are remarkable contributions by Ernst, Artaud, the defrocked priest Gengenbach, and an amusing episode concerning a donkey related by a member of the Communist Party, Jean Baldensperger. The complete text in English is to be published by Verso in 1991.

That the Surrealists played the truth game for many years is attested to by an anecdote recounted by Henri Behar in his recent biography of Breton, who quotes the critic Etiemble, enveigled into a game of it in 1941, and departing:

*. . . nauseated by the **squalid** precision, the **lewdness** and **imbecility** of this ritual.*

PAGE 95: PROVOCATIONS Roger Caillois, a cultural historian close to the Surrealists, refined the definition of the game provided by Johan Huizinga in HOMO LUDENS. Caillois describes it, in MAN, PLAY AND GAMES, as: *free (not obligatory), separate (circumscribed in time and space), uncertain (the result is not predetermined), unproductive (no goods are produced), governed by rules, and associated with make-believe.* These are qualities which could easily describe Dada and Surrealism, secret societies partially devoted to the game of ÉPATER LES BOURGEOIS in a version of unusual vehemence.

The game can be seen as a model of a more perfect social structure, which is why later groups such as the Situationists laid such emphasis upon it. Rules are accepted voluntarily since they have the opposite purpose to constraints imposed on the individual by society. Their aim is the provision of pleasure, not the imposition of repression. Freud's theory of the function of humour, which is repeatedly cited in Surrealist texts, is that it is the revenge of the pleasure principle on reality. The game has a similar function, and none more so than this GAME OF PROVOCATION in which Surrealism takes delighted revenge on its enemies.

From a massive amount of possibilities we have chosen just two: religion and etiquette and even these are hardly comprehensive.

RELIGION Sources are as follows: p 94, BIZARRE; 2, p 95, quotes from LA BRÈCHE, 4, 1963; p 96, the nun featured on the cover of BIEF, no 1, 1958; p 97 the toilet in the residence shared by Aragon, Péret, Tanguy, Prévert; p 98, from LA RÉVOLUTION SURRÉALISTE, 8, 1926 (spitting was Péret's habitual greeting for priests); p 100, one of three pamphlets issued just after the war; p 101 depicts an extract from a Catholic journal reprinted in LA BRÈCHE, 4, 1963.

PAGE 102: ETIQUETTE The text by Peter Lloyd is from Julian Levy's SURREALISM (1936), the first book on the subject published in the USA.

Magritte's play is from a letter to Marcel Mariën in 1952, first published in LES LÈVRES NUES II, 2, 1969.

PAGE 105: OBJECTS Surrealist 'objects' are associated with notions of beauty, causality and humour. The 'object' in its wider sense is the nearest thing to an autonomous 'bit' of reality; it is where the subject and outside reality and its mechanisms confront each other, a symbolic or concrete mediation between two worlds.

Breton offered a number of definitions of beauty: 'convulsive', 'exploding-fixed' — the frisson caused by the coupling of two distant terms. In the objects selected by Surrealists these attributes are embodied. Found, natural, perturbed and mathematical objects are represented by things in which a past paroxysm seems frozen and suddenly fixed. Even mathematical objects are shapes in which a grid, whose habitual form should surely be a regular net, has been twisted and deformed by the mysterious activities of equations. Interpreted objects share similar attributes, often objects of daily use whose function has been elegantly and poetically subverted by some contradictory addition (Man Ray's iron with a row of nails stuck to its smoothing surface, for example).

The found object also has a special sense, as described by Breton, who relates it to dream. Breton extended Freud's method of dream interpretation to include certain objects which seemed to him to possess a special allure.

This charged encounter with the external is what Breton refers to as 'objective chance', when causality becomes subject to desire. Such objects are the catalytic focus where two chains of events, one internal, the other external, intersect. It is a sort of destiny imposed by the subject on reality, not so much a matter of pre-ordination but rather of recognising the encounter (and subsequently decoding it). Some Surrealist constructed objects are intended to create the possibility for

this encounter artificially, to be symbolic representations of unconscious desires and motivations. For similar reasons Breton wished to put objects seen in dreams into circulation, a plan accomplished by Ferdinand Cheval in the building of his IDEAL PALACE.

PAGE 105: CATEGORIES OF SURREALIST OBJECTS The list of Surrealist objects is culled from various sources: exhibition catalogues of the 1930s, the special issue of CAHIERS D'ART (no 1/2, 1936) which was published simultaneously with the exhibition of Surrealist Objects in Paris that year, and the DICTIONNAIRE ABRÉGÉ. It is by no means exhaustive.

Dream Objects — Breton's text is from INTRODUCTION TO THE DISCOURSE ON THE PAUCITY OF REALITY, 1924.

Ferdinand Cheval's palace is certainly the most extraordinary, and probably the grandest outcome of this process. Cheval was the postman in Hauterives, a small village in central France where the palace now stands. One night in 1864, he dreamt he was constructing a great, wonderful edifice. He did nothing about it until, in 1879, he stumbled over a stone in the road. It was a piece of volcanic tufa common in the region, and its bizarre shape recalled his dream. He collected other rocks from the roadside and began building. It took him 33 years to complete his palace.

PAGE 110: OBJECTS TO FUNCTION SYMBOLICALLY Dali's explanation, in SASDLR, 6, runs thus:

These objects, which are adapted to a minimum of mechanical function, are based on phantasms and representations capable of being provoked by the realisation of unconscious actions.

Actions whose realisation does not explain the pleasure derived from them, or which bear witness to the mistaken theories elaborated by censorship and repression. In every case analysed, such actions correspond to clearly characterized erotic fantasies and desires.

The incarnation of these desires, their manner of objectifying themselves via displacement and metaphor, and their symbolic realisation, constitute the process typified as sexual perversion, *whose every aspect resembles that of poetic activity.*

PAGE 118: EXPERIMENTS WITH OBJECTS The accounts of the first two of these experiments are from SASDLR, no 6, 1933. The remainder are from Dali's THE OBJECT AS REVEALED IN SURREALIST EXPERIMENT (THIS QUARTER,

September 1932). The description of the method is from the article by Arthur Harfax and Maurice Henry in SASDLR. Dali prefaced his proposed experiments with a description of the Surrealist laboratory:

All night long a few Surrealists would gather round the big table used for experiments, their eyes protected and masked by thin though opaque mechanical slats on which the blinding curve of the convulsive graphs would appear intermittently in fleeting luminous signals, a delicate nickel apparatus like an astrolabe being fixed to their necks and fitted with animal membranes to record by interpenetration the apparition of each fresh poetic streak, their bodies being bound to their chairs by an ingenious system of straps, so that they could only move a hand in a certain way and the sinuous line was allowed to inscribe the appropriate white cylinders. Meanwhile their friends, holding their breath and biting their lower lips in concentrated attention, would lean over the recording apparatus and with dilated pupils await the expected but unknown movement, sentence or image.

The presentation here of the first two experiments is somewhat misleading, in that the purpose of these investigations was the discovery of common ground between participants — giving only one player's answer to each question precludes this. In the original published version, the answers to each of these games occupy approximately two large pages of very small print (each player answered nearly all the questions) — impossible to reproduce here.

Three other investigations appeared with the 'piece of pink velvet' and the 'city': A CRYSTAL BALL; IRRATIONAL POSSIBILITIES OF ORIENTING AND PENETRATING A PAINTING BY GIORGIO DE CHIRICO; and ON THE IRRATIONAL POSSIBILITIES OF LIVING AT A CERTAIN DATE (THE YEAR 409). Harfax and Henry mention other objects which had already been investigated: a piece of coral, a soup-spoon, sock-suspenders etc..

PAGE 118: TO DETERMINE THE IRRATIONAL CHARACTERISTICS OF OBJECTS: *A Piece of Pink Velvet* 1. Nocturnal 75%. 2. Favourable 92%. 4. The face 50%, feet 25%. 5. Antiquity 25%, between 14th and 19th centuries 75%. 6. Fire 50%, air 33%. 7. Women cited by 42%; Saint-Just by 16%. 8. Drowning 25%. 9. 'Esthetic' objects 25%, the rest harder to analyse. 10. Veiling the face 33%. 11. No great correlation, in the mouth 16%. 12. Hysteria 25%, respiratory illnesses 42%. 13. The 'better' parts of Paris 33%, Place Vendôme 16% 14. Prostitution 33%, 'pleasant' occupations 25%. 17. 11 languages, only Irish cited twice. 18. The poets remarkable for their sentimentality. 19. All female. 20. Methods connected with the feet 25%, cutting 33%. 22. Female perversions 33%. 24. No particular correlation, Monet cited twice.

PAGE 120: CERTAIN POSSIBILITIES RELATING TO THE EMBEL-LISHMENT OF A CITY *Paris* The analysis of results in this experiment is harder to summarise. Eluard (in the same issue of SASDLR) notes that many responses are prompted by disgust and hatred for the object transformed, as well as the presence of many feminine characteristics in the new monuments. Statues are transformed so as to give an accurate representation of their subjects' worth, bones are associated with the Opéra, certain monuments are considered as taboo etc..

We have tried to beautify a little, physically and morally, the face of Paris, across which so many corpses have left their mark.

PAGE 122: AUTOMATIC SCULPTURE The photograph is from an article in MINOTAURE, no. 3/4, 1933, in which Dali compares the results of automatism to Art Nouveau architecture, which he characterises as 'solidified desire'.

PAGE 124: SURREALIST CARD PACK In 1940 a number of Surrealists found themselves stranded in Marseilles from where they were to sail to America to escape the war. (Breton's faction had few friends among the Stalinist and Gaullist wings of the Resistance, and none among the Fascist or Pétainist administrations.) While waiting, they invented this pack of cards; the drawings of the 'court' cards are by Brauner, Breton, Dominguez, Ernst, Herold, Lam, Lamba and Masson. They were redrawn for publication by Robert Delanglade, in order to give them a more uniform appearance.

Among the people represented are Mariana Alcoforado, the Portuguese nun, author of a number of celebrated love letters dating from 1667, now considered probable forgeries; Lautréamont, pseudonym of Isidore Ducasse, author of LES CHANTS DE MALDOROR; Lewis Carroll's ALICE; Lamiel, from the novel by Stendhal; Pancho Villa, the Mexican revolutionary; Hélène Smith, the 19th century medium and prolific automatic writer; Ubu, anti-hero of UBU ROI by Alfred Jarry.

PAGE 126: THE NEW GAME OF LOTTO was published by ÉDITIONS DE L'ATHANOR in 1974.

PAGE 127: Paul Nougé's photographic collection SUBVERSION DES IMAGES was published by LES LÈVRES NUES in 1968, although dating from the 1930s. This photograph, THE JUGGLER, appeared on the cover.

PAGE 128: PROVERBS FOR TODAY Eluard and Péret's 152 PROVERBES MIS AU GOÛT DU JOUR was first published as a booklet in 1925.

Other proverbs come from Breton and Eluard's THE IMMACULATE CONCEPTION (the final section).

PAGE 130: Péret's new superstitions terminate an article in the catalogue to the exhibition LE SURRÉALISME EN 1947.

PAGE 131: NEW MYTHS Breton's text is from PROLÉGOMÈNES À UN TROISIÈME MANIFESTE DU SURRÉALISME OU NON, 1942. The illustration, from Maier's SCRUTINIUM CHYMICUM (1687), was reproduced in a section devoted to new myths in FIRST PAPERS OF SURREALISM (1942).

To some extent the Surrealist project can be seen as a search for, and intervention in, the new myths underlying contemporary history, the unconscious current beneath everyday events. THE GREAT TRANSPARENT ONES is an eloquent statement of this quest. Part of Breton's rejection of the position of the 'artist' was his belief that personal creativity produced only a personal mythology, the task and importance of collective activities being the creation of collective myths. In ENTRETIENS (1954) Breton recalls with approval an observation made by Georges Bataille: that the supposed absence of myth is perhaps the true myth of today.

PAGE 132: THE NEXT GAME The quote from Jouffroy is from his polemic on May '68, FOR A MUCH GREATER GAME, NEXT TIME (PHANTOMAS 82, 'Homo Ludens' issue, 1968).

PAGE 133: SURREALIST BIBLIOGRAPHY Seligmann's bibliography appeared in VVV, 2/3, 1943. It has been edited to exclude names not cited in this book.

GAMES OMITTED FROM THIS SELECTION

A brief chronological list of known games omitted for various reasons (repetition, impossibility of adequate presentation etc.). Photographic methods are not included in this book (Man Ray's SOLARISATION, Unik's FOSSILISATION, Hare's BRULAGE, etc.). These seem more experimental than ludic. As we go to press we hear that the Czech Surrealists' magazine ANALGON, able to publish for the first time since the Prague Spring, is devoting issue no. 7 to games. The Czech group has been active since the 1930s, clandestinely for most of the last few decades. Finally, we have, of course, had to leave out one large area of word-games which is very important in Surrealism: games based on puns. These can only be presented in their original language.

LE VOYAGE MAGIQUE, 1923. A journey to places picked at random made by Breton, Morise, Aragon and Vitrac. The latter's account VOYAGE MAGIQUE seems never to have appeared.

LE JEU DES MOTS ET DU HASARD, Paul Nougé, 1925 (but not published until 1955). Cards bearing various phrases that can be shuffled to produce poems.

CONCERNING THE PRESENT DAY RELATIVE ATTRACTIONS OF VARIOUS CREATURES IN MYTHOLOGY AND LEGEND, (collective), VVV, 1, 1942. A 'scholarly notation' in which the Sphinx comes out on top.

DESSIN SUCCESSIF, (collective), VVV, 2/3, 1943. Chain drawings; each player looks at the previous player's drawing for five seconds then repeats it.

DATA TOWARDS THE IRRATIONAL ENLARGEMENT OF A FILM: Shanghai Gesture, (collective), L'AGE DU CINÉMA, 4/5, 1951 (in English in THE SHADOW AND ITS SHADOW, SURREALIST WRITINGS ON THE CINEMA, Paul Hammond, BFI, 1978, new edition from Polygon imminent). Inquiry into a specific film: speculations on aspects which do not appear on the screen.

Games from 30 ANS DE SURRÉALISME, PLEINE MARGE, 1989 (bookseller's catalogue). These date from the 1950s (source of THE GAME OF SYLLOGISMS). QU'EST-CE QUE . . . C'EST . . . Variant of Questions & Answers.

QUI EST MÉDIUM? Inquiry.

ENQUÊTE SUR LA CONNAISSANCE IRRATIONELLE DU MÉTRO.

LES ANIMAUX SURRÉALISTES. Ten favourite animals inquiry.

QUELS SONT LES TROIS . . . Inquiry: what 3 people, ideas or objects would you have disappear?

ENRICHISSEZ VOTRE VOCABULAIRE, (collective), LA BRÉCHE, 3, 1962. Players define the same imaginary word.

POÈME-SQUELETTE, Petr Kral, COUPURE, 1, 1969. Poem based on marker-words.

JEU DE LA JETÉE D'OMBRE, Bernard Caburet, BLS, 1, 1970. Board game.

JEU DE LA MÉDITATION EN CHAINE, (collective), Coupure, 7, 1972. Longer version of chain writing; players see previous contributions, but the exact method is obscure.

OBJETS PARALLELS, François Raffinot and Dominique Lambert, BLS, 5, 1972. Object version of parallel stories; players add to, or subtract from, identical objects.

LE THÉÂTRE EN 1973, (collective), BLS, 8, 1973. Collaborative theatre scripts created by a similar process to Question and Answer.

THE ANA-RHYME, Steven Zivadin, Oxford, 1974. A proposal for a new type of poetic rhyme, not based on phonetics, but on words sharing the same consonants in different orders.

JEU D'INTERPRÉTATION, (Czech Surrealists), BLS, 9, 1974. Collaborative picture-making.

NOUVEAU JEU DE L'OIE & NOUVEAU JEU DE DOMINOS, Guy and Rikki Ducornet, Soror 16 (BOUCHE À BOUCHE), 1975. Another version of the 'Dominoes' appeared in PHASES, II, 5, 1975.

TIME TRAVELLER'S POTLACH, ARSENAL, 3, 1976. Inquiry: what gift would you give various celebrated historical characters?

LE RESTAURATEUR, Jan Svankmajer, SURRÉALISME, 1, 1977. Object inquiry game.

FURTHER READING IN ENGLISH

This is a very brief list of the more important publications available in English; it does not include 'art' books. Titles published in London unless indicated otherwise.

● General surveys

Maurice Nadeau, THE HISTORY OF SURREALISM, tr. R Howard, Cape & Penguin.
Patrick Waldberg, SURREALISM, Thames & Hudson.
Roger Cardinal & Robert Stuart Short, SURREALISM: PERMANENT REVELATION, Studio Vista.

● The best anthologies

Marcel Jean, THE AUTOBIOGRAPHY OF SURREALISM, Viking, NY.
J H Matthews, THE CUSTOM-HOUSE OF DESIRE, California University Press.
Michael Benedikt, THE POETRY OF SURREALISM, Little, Brown & Co, Chicago.
Robert Motherwell, THE DADA PAINTERS AND POETS, Wittenborn, N.Y.
(Collective), RESEARCHES INTO SEXUALITY, Verso (forthcoming).

● Individual authors

Louis Aragon, PARIS PEASANT, tr. S W Taylor, Cape & Paladin.
Louis Aragon, TREATISE ON STYLE, tr. A Waters, Nebraska University Press.
Louis Aragon, THE LIBERTINE, tr. J Levy, Riverrun N. Y. & Calder
Jean Arp, COLLECTED FRENCH WRITINGS, tr. J Neugroschel, Calder.
Antonin Artaud, COLLECTED WORKS I, II & III, various trans., Calder.
André Breton, MANIFESTOS OF SURREALISM, tr. Seaver and Lane, University of Michigan Press.
André Breton, LE CADAVRE EXQUIS, SON EXALTATION, (in 3 languages), Schwarz, Milan.
André Breton, NADJA, tr. R Howard, Grove Press, NY.
André Breton/Philippe Soupault, THE MAGNETIC FIELDS, tr. D Gascoyne, Atlas Press.

André Breton/Paul Eluard, THE IMMACULATE CONCEPTION, tr. J Graham, Atlas Press.

André Breton/Eluard/Char, RALENTIR TRAVAUX, tr. K Waldrop, Exact Change, Cambridge, USA.

Leonora Carrington, THE HOUSE OF FEAR., Virago

Leonora Carrington, THE SEVENTH HORSE Virago.

Leonora Carrington, THE HEARING TRUMPET, City Lights, San Francisco.

Aimé Césaire, COLLECTED POETRY, tr. C Eshleman & A Smith, University of California Press.

René Crevel, BABYLON, tr. K Boyle, North Point, San Francisco.

René Crevel, DIFFICULT DEATH, tr. D Rattray, North Point, San Francisco.

Robert Desnos, GRIEF UPON GRIEF, tr. Terry Hale, Atlas Press (forthcoming).

René Daumal, MOUNT ANALOGUE, tr. R Shattuck, Penguin.

Rikki Ducornet, THE STAIN, Chatto & Windus

Rikki Ducornet, ENTERING FIRE, Chatto & Windus.

Rikki Ducornet, THE BUTCHER'S TALES, Atlas Press.

Paul Eluard, SELECTED POETRY, tr. G Bowen, Calder.

Theodor Flournoy, FROM INDIA TO THE PLANET MARS, tr. D Vermilye, Harpers, NY (1900).

Julien Gracq, THE CASTLE OF ARGOL, Lapis Press (forthcoming).

Michel Leiris, AURORA, tr. A Warby, Atlas Press.

Michel Leiris, BRISÉES: BROKEN BRANCHES, North Point, San Francisco,

Benjamin Péret, DEATH TO THE PIGS AND OTHER WRITINGS, tr. R Stella, Atlas Press.

Alberto Savinio, THE LIVES OF THE GODS, tr. J Brook, Atlas Press.

Raymond Roussel, LIFE, DEATH & WORKS, ed. A Brotchie, Atlas Press.

Raymond Roussel, SELECTIONS FROM CERTAIN OF HIS BOOKS, various trans., Atlas Press.

Tristan Tzara, CHANSON DADA, tr. Lee Harwood, Underwhich Editions, Canada.

Tristan Tzara, 7 DADA MANIFESTOS AND LAMPISTERIES, tr. Barbara Wright, Calder.

LITTLE SURREALIST DICTIONARY

A GAME OF RE-DEFINITIONS

'Our heads are round so that our thoughts can fly in any direction.'

FRANCIS PICABIA

aeroplane, A sexual symbol useful for getting rapidly from Berlin to Vienna. [attributed to FREUD]

annihilated, Annulled, by inhaling nothingness. [LEIRIS]

anthrax, Giant of Greek mythology, son of Thorax and Erysipelas, ravisher of the nymph Acne.

aphorism, The aphorism is a poultice of consolation. [PANSAERS]

aquarium, Humid square of requiems. [LEIRIS]

art, Art is a pharmaceutical product for imbeciles. [PICABIA]

ash, A disease of cigars. [PÉRET]

atomizer, Built to please the Khmer king who had the idea of squeezing the peel of a tangerine into a flame.

attic, The idea of removing it from dwellings goes back to Caius Gracchus' favourite slave. She hoped in this way to keep the swallows nesting in the roof from leaving in the autumn. [PÉRET]

axiom, Fixed miasma, malign aroma ... [LEIRIS]

beauty, Beauty is simply the total consciousness of our perversions. [DALI] Beauty shall be convulsive or it will not be ... Convulsive beauty shall be erotic-veiled, explosive-fixed, magical-circumstantial, or not be. [BRETON]

belief, Beliefs are ideas going bald. [PICABIA]

billiards, Constructed for the purpose of a demonstration by Pico della Miran-dola, who wished to establish that human dialogue depends on nature and is only opposed (not insurmountably) by the sun. [BRETON & PÉRET]

boat, Looking at the sea being ploughed by boats, the Buddhist priest Kanguen asked his disciple Daichi *'Could you from your room stop these boats sailing past?'* The young disciple closed the shutters. Then the master said: *'All the same, you couldn't have stopped that boat if you'd had no hands'.* The young disciple shut his eyes.

bordello, Small cradle on casters used by the Bordelais — *She placed her daughter in a bordello.*

buttons, Made fashionable by Isabella of Bavaria, who secured her blouse with snowdrops. [BRETON & PÉRET]

cadence, Quadrature of silence. [LEIRIS]

causality, *'Notions of cause and effect concentrate on and are bound up with that of universal interdependence in whose womb cause and effect incessantly change place'.* [ENGELS]

chaos, Cloaca. Not yet encased, where causes croak. [LEIRIS]

chance, *'Chance would be the manifestation of the exterior necessity which battles its way through man's unconscious.'* [BRETON]

cocteau, A variety of small cock with attractive plumage and a taste for ostentatious display, becomes restive if forced to work. *The cocteau is not a good breeder.* [ANDRÉ GIDE]

credulity, Normal rather than morbid characteristic of the human race. Important because of its consequences, notably the body's position during sleep. [COLINET & KINDS]

cynicism, The worm of mockery that spoils the otherwise delicious fruit of complete freedom. [LEGRAND]

dada, Dada is a virgin microbe that with the fickleness of air enters all the

EROTICISM

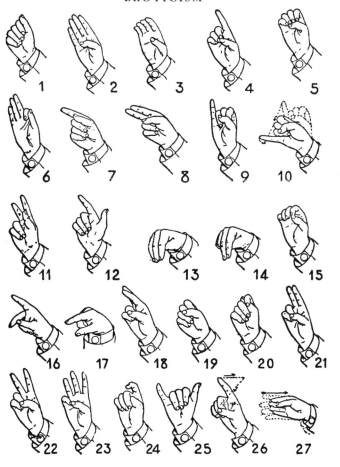

1. Accost. 2. Burgle. 3. Cunnilinguate. 4. Deflower. 5. Ensnare. 6. Fuck. 7. Gallivant.
8. Harass. 9. Irrumate. 10. Jismify. 11. Kink. 12. Lesbianise. 13. Masturbate.
14. Nidify. 15. Occult. 16. Pedicate. 17. Quench. 18. Ream. 19. Syphilize.
20. Tup. 21. Urticate. 22. Violate. 23. Waggle. 24. Xiphoidify. 25. Yonirise.
26. Zoogonise. 27. Recommence.

spaces reason has not been able to overload with words or conventions. [TZARA] Dada puts mustard in the ciboria, urine in the fonts, and margarine in the artists' tubes of paint. [RIBEMONT-DESSAIGNES]

death, Death is the horizontal prolongation of a factitious dream, life not being verifiable. [PICABIA] If you want to die, just carry on! [DADA PROVERB]

debauch, Special organisation of one's private life as reaction against social insanity. [SCHUSTER]

decalcomania, During a costume ball given in 1854 at the court of Napoleon III, Seymour appeared disguised as a prowler, his forehead covered with false tatoos reproducing the portrait of Gabrielle d'Estree with the Duchess of Villars. [BRETON & PÉRET]

depravity, Descending the ascending path of pleasure. [MIMI BENOIT]

dog, A dog is not a hammock. [SERNER]

dream, Dream is a tunnel running beneath reality. [REVERDY]

ejaculation, According to the PETIT LAROUSSE ILLUSTRÉ, a short prayer uttered with fervour. Its brevity is generally to be deplored, as is its tendency, among certain people, to frequent repetition, which is strictly contrary to the express instructions of the Ecclesiastical Authorities. A prickly problem of conscience then, which artists, writers and financiers alone have resolved, so far as it affects them, by employing it with the strictest economy.

elephant, Puffed up elf. [LEIRIS] Elephants are contagious. [ELUARD & PÉRET]

enemy, All our enemies are mortal. [VALÉRY]

eternity, Eternity begins and ends in bed. [ELUARD]

folklore, Acid chemical product extracted with great difficulty from the earth.

fornication, A chemico-mechanical operation consisting of softening iron bars and then tempering them in a vat of water brought to boiling point. [DICTIONARY OF REDISCOVERED WORDS]

fossil, Hypnagogic invention of Leonardo da Vinci. [DALI]

future, The future is a monotonous instrument. [PICABIA]

infinity, There are two infinities: God and stupidity. [VARÈSE]

knowledge, The known is an exception, the unknown a deception. [PICABIA]

lace, Created especially for Laure de Cléry who had desired a 'glade-coloured' nightshirt.

literature, One of the saddest roads that leads to anything. [BRETON]

madness, The mad are those who have lost their mirrors. Suppress mirrors. [RIGAUT]

masturbation, The hand at the service of the imagination. [MIMI BENOIT]

morality, Morality is the backbone of half-wits. [PICABIA]

music, Music is the diarrhoea of the intellect. [RIBEMONT-DESSAIGNES]

mustard, Produced in 1165 at the request of the anti-pope Guido da Crema, who was looking for anti-honey. [BRETON & PÉRET]

ovaries, Ovals devoured by Eve. [LEIRIS]

paradise, All paradises are artificial. [ARAGON]

perception, *'One can affirm the presence or perception of an object when it is present and perceived, when it is absent and perceived, when it is neither present nor perceived'.* [QUERCY]

perversion, The infinite variations of the sexual urge have been condensed by Freud in a famous and still scandalous formula: *'The child is polymorphously perverse.'* LEGRAND

phallus, The phallus is exoteric in bed but usually esoteric in the street. [PICABIA]

phallustrade, It is an alchemical product, composed of the following elements: *autostrade,* balustrade and a certain quantity of phallus. A phallustrade is a verbal collage. [ERNST]

poem, A poem must be intellect's débacle. [BRETON & ELUARD]

providence, All approved accidents. [LEIRIS]

red eggs, At the turn of the century, eggs given to the May Day demonstrators by shopkeepers posted along the parade route.

revolving doors, Built at the request of the owner of the Café Anglais who, to honour Evans on his return from Crete, reduced the labyrinth to its simplest expression. [BRETON & PÉRET]

sacrifice, Factitious solstice; acrid chalice, riddled with cicatrix. [LEIRIS]

sanctity, *'The notion of the "soul", "spirit" and eventually even the "immortal soul", was invented so as to bring to everything in life deserving of serious consideration — food, lodging, learning, health, cleanliness, warmth — only the most appalling thoughtlessness'.* [NIETSZCHE]

scandal, Sudden disclosure, for purposes of provocation or challenge, of what society and conventional morality tolerates only when camouflaged: the 'shameful' human pudenda, man's exploitation of man, the existence of torture, but also any outburst too unendurable from a person out of step with his surroundings. [NORA MITRANI]

sea, The sea is the night asleep in the daytime. [DESNOS]

sex, The act of sex is the axis of sects. [DESNOS]

shadow, The shadow precedes man, the assassin follows close behind. [NAVILLE]

suicide, Suicide must be a vocation. [RIGAUT]

surrealism, *'The vice known as Surrealism consists of the disordered and passional application of the stupefying image'.* [ARAGON]

'Surrealism, in its wider sense, represents the most recent attempt to break with things as they are and to substitute for them other things — immediately operational and fully-formed — whose shifting contours are inscribed in filigree in the very depths of being.' [RAYMOND]

termite, Monk belonging to a very strict order, now extinct, whose principle rule was to put an end to all human activity. [*The Devil turned Termite* SAINTE-BEUVE]

thought, Thought is considering death and taking a decision. [RIGAUT]

virtue, Virtue is perfumed with crime. [DURTAIN]

yes, Yes = No. [PICABIA]

The definitions in this mini-dictionary are taken from the following sources: DICTIONNAIRE ABRÉGÉ DU SURRÉALISME, 1938, edited by Breton & Eluard; LEXIQUE SUCCINCT DE L'EROTISME, 1959, collectively edited; the DICTIONNAIRE GÉNÉRAL which appeared in the review DOCUMENTS, 1929-30, edited by Georges Bataille; CALENDRIER TOUR DU MONDE DES INVENTIONS TOLÉRABLES, 1950, by Breton & Péret; the DA COSTA ENCYCLOPÉDIQUE, 1947, anonymously and collectively edited; PETIT DICTIONNAIRE ARBITRAIRE, 1970, edited by Annie LeBrun; DICTIONNAIRE DE MÉDECINE AMUSANTE, 1971, by Colinet & Kinds; PETIT DICTION-NAIRE DES MOTS RETROUVÉS, 1954, collective; PETITE FOLIE COLLECTIVE, 1966, edited by Michel Corvin; GLOSSAIRE, J'Y SERRE MES GLOSES, 1939, by Michel Leiris.

TOLENTINO (*lin*), v. d'Italie (prov. de Macerata); 11.400 h. Traité de 1797 entre Bonaparte et le pape, consacrant la réunion d'Avignon à la France.

TOLOSA, v. d'Espagne (Guipuzcoa); 10.000 h. Fabrication de toiles.

TOLSTOÏ (Pierre, *comte de*), diplomate russe, conseiller de Pierre le Grand (1645-1729).

TOLSTOÏ (Léon, *comte*), romancier et moraliste russe, né à Iasnaïa-Poliana en 1828, m. à Astapovo en 1910. Principales œuvres: *Guerre et Paix, Anna Karénine*, etc. Où il excelle à peindre la vie et les mœurs russes. Comme théoricien et moraliste, il cherche à se rapprocher du christianisme primitif.

TOLTEQUES, peuplade du Mexique, supplantée par les Aztèques au xiie siècle.

TOLU, v. de Colombie, près de la mer des Antilles; 1.000 h. Baume dit de *Tolu*.

TOLUCA, v. du Mexique, ch.-l. de l'État de Mexico; 31.000 h. Chapellerie.

TOM, rivière de Sibérie, aff. de l'Obi; 843 kil.

TOMASZOW, v. de Pologne, gouv. de Lodz, près de la Pilica; 28.500 h. Grande industrie textile.

TOMBOUCTOU (Afrique-Occidentale française, Soudan français), près du Niger, occupée par les Français en 1893; 7.220 h. Entrepôt de commerce.

TOMES ou TOMI, anc. v. de la Mésie, où le Pont-Euxin, où Ovide mourut en exil.

TOMMASEO (Nicolas), érudit et homme politique italien (1802-1874).

TOMSK, v. de Sibérie, sur le Tom; ch.-l. de gouv.; 90.600 h.

TON, une des ÎLES DES AMIS, archipel de la Polynésie; 23.500 h. Capit. *Noukoualofa*. A l'Angleterre.

TONCHI, qui occupe la région pyrénéenne...

TONGRES, v. de Belgique (Limbourg); 10.500 h. Eaux minérales.

TONKIN, pays de l'Indochine française, dépendant près du Royaume d'Annam; 6.870.000 h. (*Tonkinois*). Ch.-l. *Hanoï*. C'est proprement la vallée du fleuve Rouge et de ses affluents, à rivière *Rouge*, la rivière Claire. Dans très fertile du fleuve Rouge. Riz, céréales, thé, bois de construction, nombreuses richesses minérales.

L'idée d'un établissement colonial sur la côte de l'Indochine, né sous Louis XVI...

TOYNIN (*sociéle et homme politique entre l'Annaïsce* (Loere) [1762-1833]).

TONNAY (*la*), praticien et philosophe aréo-Inféres, fondateur du poète Jeanne.

TONNAY, v. positive cat une des pauvres de l'actié de M.

TONNERRE, arr. de Madame...

TOPFER (le *la* sss; 50.000 Myth.)

TOPINAMBI suisse, ne des Foyas Age maine fané...

TORDESILLAS, v. d'Espagne (Valladolid)...

TORELLI (le *la*)...

TORGAU, v. de Prusse (Saxe), sur l'Elbe...

TORIGNI...

TORQUEMADA...

TORRE (451), de Constantinople (353)...

TORRICELLI (Evangelista), physicien italien...

TOSA...

TOSCANE, anc. Étrurie, anc. grand-duché d'Italie...

AUG. COMTE (Finistère), arr.

LABASTIDE-L'AIRENCE, ch.-l. de c. (Basses-Pyrénées, arr. de Bayonne, sur l'Aran; 1.180 h.

LABASTIDE-MURAT (*ma*), ch.-l. de c. (Lot), arr. de Gourdon, près du Céou; 900 h.

LABAT (*bal*) (le *Père* Jean-Baptiste), missionnaire français, né à Paris. Il contribua à la colonisation de la Guadeloupe (1663-1738).

LABBE (le *Père* Philippe), jésuite français, né à Bourges (1607-1620), auteur de la *Collection générale*...

LABBE (Léon), chirurgien français, né au Merle-ault (1832-1916). Membre de l'Académie des sciences.

LABBE (Louise), femme poète française, née à Lyon 1526, fille et femme de corliers, surnommée *la Belle Cordière*, vers 1566.

LA BEAUMELLE (Laurent Angliviel de), littérateur et Valleragne (Gard), connu sur ses querelles avec Voltaire (1726-1773).

LAREDOYERE (Charles), général français, né à Paris en 1786, fusillé en 1815.

LABICHE (Eugène), auteur dramatique français, né à Paris. Il eut douze d'une spirituelle fécondité, d'une grande verve et d'une gaieté irrésistible...

LABIEN (*le*), lieutenant de César (2e s. av. J.-C.)

ardente conviction scientifique, qui croire l'humanité susceptible d'un progrès m. altitude. (1743-1794).

CORBBIAC, ch.-l. de c. (Rhône), près du Rhône; 2.000 h. Ch.-l. F. Mercerie, résiné; fruits.

CORGLIANO, v. forte d'Italie (V. de Montalcino); 13.200 h. Draps, soierie.

CONEGLIANO (Cima da), peintre italien né à Conegliano (vers 1460 - vers 1520). Archichapelle de premier ordre...

CONEJAVA, l'une des îles Baléares; suivant une quantité prodigieuse espagnol *conejo*.

CONFÉDÉRATION GERMANIQUE. États allemands, décrétée par le Congrès se rompue en 1866 Alors, la Prusse victorieuse Sadowa chassa l'Autriche de la confédération laquelle à la tête duquel se mit la nature et ne songeait plus qu'à lui imposer...

F. LABICHE

VIGNOLE

TOYNIN (*iciste et homme politique*...)

ROPBUROEN (*san*), ch.-l. de c. de Bar...

ESPOLISS (*can*), ch.-l. r. (Loir-et-Cher), sur le; ch. de fer Orl. et Blois; 9.300 h., au N.-O. de Blois; 9.300 h. (*dômois*). Grains et bestiaux.

VENDOME.

MAINE-ET-LOIRE

VILAS, ch.-l. de c. de la Moselle, arr. de Metz-Campagne; 610 h.

VIRIEBEN (*vi-f*), ch.-l. de c. (Maine-et-Loire), arr. de Saumur; 1.660 h.

VIRIVAS (*fi-f*), pillard scandinave, qui, du xie au xiiie siècle, ravagèrent l'Europe de leurs...

VILAINE (*le vil-la*), fleuve de France, prend sa source dans le dép. de la Mayenne, baigne Vitré, Rennes, Redon, et se jette dans l'Atlantique; 225 kil.

VILLACH (*vil-lak*), v. d'Autriche (Carinthie), sur la Drave; 21.900 h. Eaux minérales.

VILLAMANCA, v. d'Espagne; ch.-l. de c.

VILLANDRAUT, ch.-l. de c. (Gironde), arr. de Langon; 1.400 h. (*Villandrautins*).

VILLANI (Giovanni), historien italien, né à Florence, auteur de célèbres *Histoires florentines* (1276-1348).

VILLARD-DE-LANS (*lar-de-lanss*), ch.-l. de c. (Isère), arr. de Grenoble; 1.630 h.

AD. VIGNY

LIBRARY OF CONGRESS
CATALOGING-IN-PUBLICATION DATA

SURREALIST GAMES.
A BOOK OF SURREALIST GAMES/COMPILED AND EDITED BY
ALASTAIR BROTCHIE; EDITED BY MEL GOODING
P. CM.
ORIGINALLY PUBLISHED: SURREALIST GAMES. BOSTON :
SHAMBHALA REDSTONE EDITIONS, 1993.
INCLUDES BIBLIOGRAPHICAL REFERENCES.
ISBN 1-57062-084-9
1. SURREALIST GAMES. 2. ARTS, MODERN—20TH CENTURY—
THEMES, MOTIVES. I. BROTCHIE, ALASTAIR.
II. GOODING, MEL. III. TITLE.
NX456.5.S8S88 1995 94-23690
700—DC20 CIP